20 WAYS TO DRAW A JELLYFISH

AND 44 OTHER AMAZING SEA CREATURES

TRINA DALZIEL

A Sketchbook for Artists, Designers, and Doodlers

Quarry Books
100 Cummings Center, Suite 406L
Beverly, MA 01915

quarrybooks.com • www.craftside.net

© 2015 by Quarry Books
Illustrations © 2015 Trina Dalziel

First published in the United States of America in 2015 by
Quarry Books, a member of
Quarto Publishing Group USA Inc.
100 Cummings Center
Suite 406-L
Beverly, Massachusetts 01915-6101
Telephone: (978) 282-9590
Fax: (978) 283-2742
www.quarrybooks.com
Visit www.Craftside.Typepad.com for a behind-the-scenes peek
at our crafty world!

10 9 8 7 6 5 4 3 2 1

ISBN: 978-1-63159-069-6

Design: Debbie Berne

Printed in China

CONTENTS

INTRODUCTION

The ocean covers more than two thirds of the world. There are thousands of different types of animals living in it and new creatures are still being discovered. There are parts of the oceans that are as unknown to us as outer space—places where no one in the world has ever been.

Perhaps you have had the experience of scuba diving in the ocean or have been to an aquarium. I truly believe the best way to learn to draw something is by studying it in real life, but sometimes this isn't possible—do you have an octopus in your bath or a sea otter in your sink?

walruses:
inks and brushes

HOW TO USE THIS BOOK

Each double page shows a sea creature drawn in twenty different styles and allows space for you to draw. You may want to start by copying a few of the drawings to get a feel for the form. In some drawings I have simplified these creatures into linear or geometric shapes to show how complex forms can be built from basic ones. You might want to do the same and then add your own details to bring them to life.

Think about the emotions of the things you are drawing. How do you draw an angry shark versus a gentle shark? Does it make you hold your pen or pencil differently? Also think about your own emotions. When you are happy or shy or angry, does it affect the type of marks you make?

Another approach to drawing is to ask if you were creating this in a different way, how would it look? If you were embroidering a whale, or sculpting a walrus, how might it look? Would you maybe use tiny marks like stitches or big, smooth pencil marks?

Experiment with different media and drawing tools. Try new materials that you may not be familiar or comfortable with—if you are typically very neat, try charcoal; if you are a messy artist, experiment with a fine-tipped pen. You might surprise yourself and fall in love with a new tool!

We all see things differently—diverse things catch our eye. What fascinates you? Is it the pattern on the creature, the way it moves, or its structure or color? Focus on what attracts you most.

Sometimes it is a useful exercise to emulate the style of another artist whose work is very different from yours. It can pro-vide you with new ideas for mark making and help you develop a new way of seeing. If you ever copy another artist's work as an exercise, always note the influencing art-ist's name next to it to remind you that it wasn't your original idea. See this process as a starting point—never as final art.

sea stars: colored pencils

Can you find additional ways to draw these creatures? You might want to choose some of the animals and find out more about them. The more you know about a subject, the easier it becomes to draw. Or, can you think of other sea crea-tures to draw in twenty different ways that aren't featured in this book? Or perhaps you could invent some undiscovered creatures from the deep—from deep under the ocean and deep in your imagination. However you approach this book, just remem-ber, have fun and enjoy the process!

anemones: felt-tipped markers

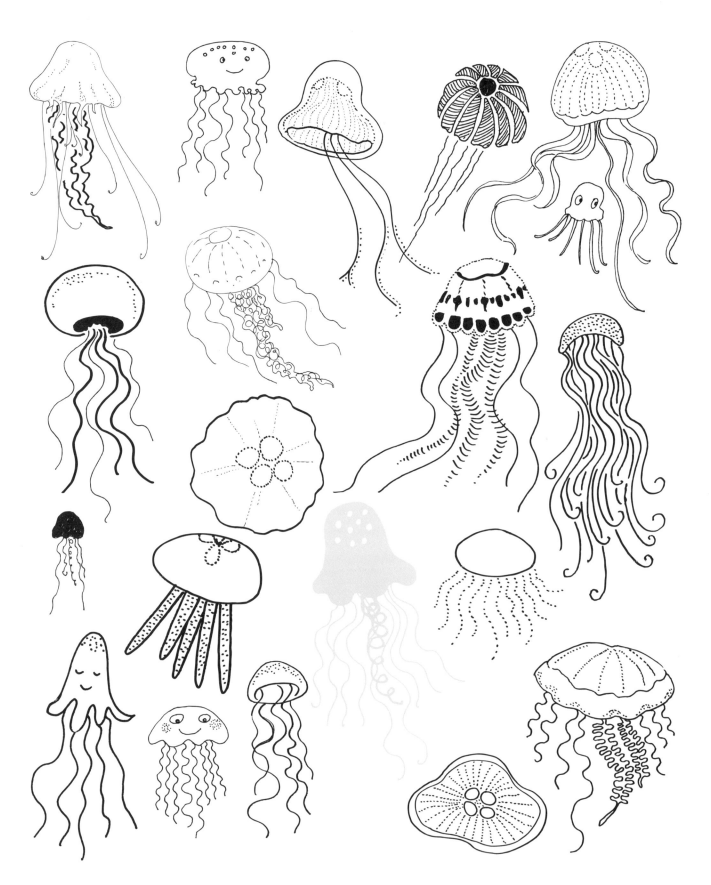

DRAW 20
Jellyfish

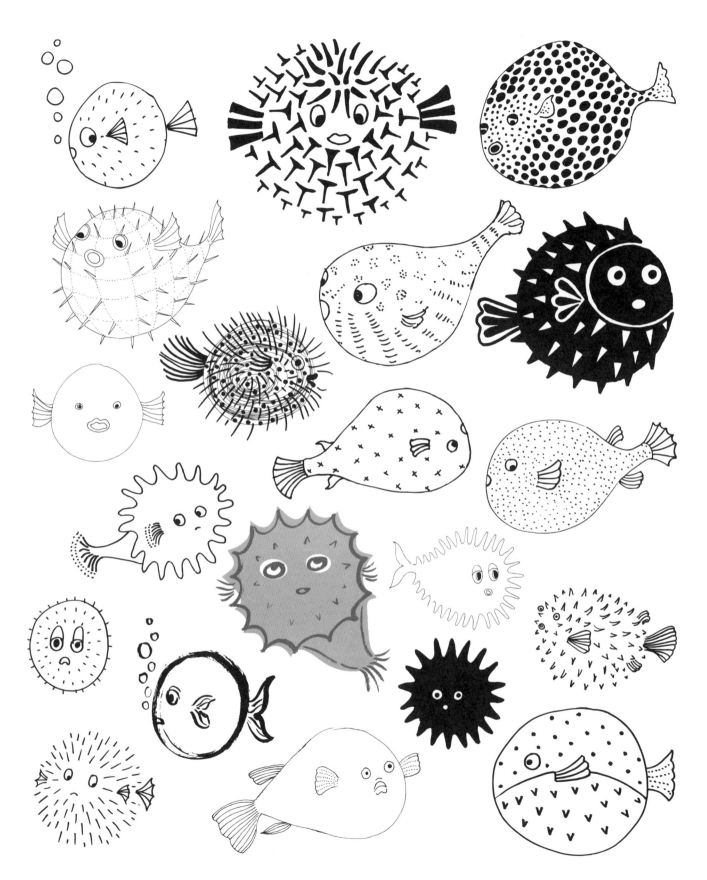

DRAW 20
PUFFER FISH

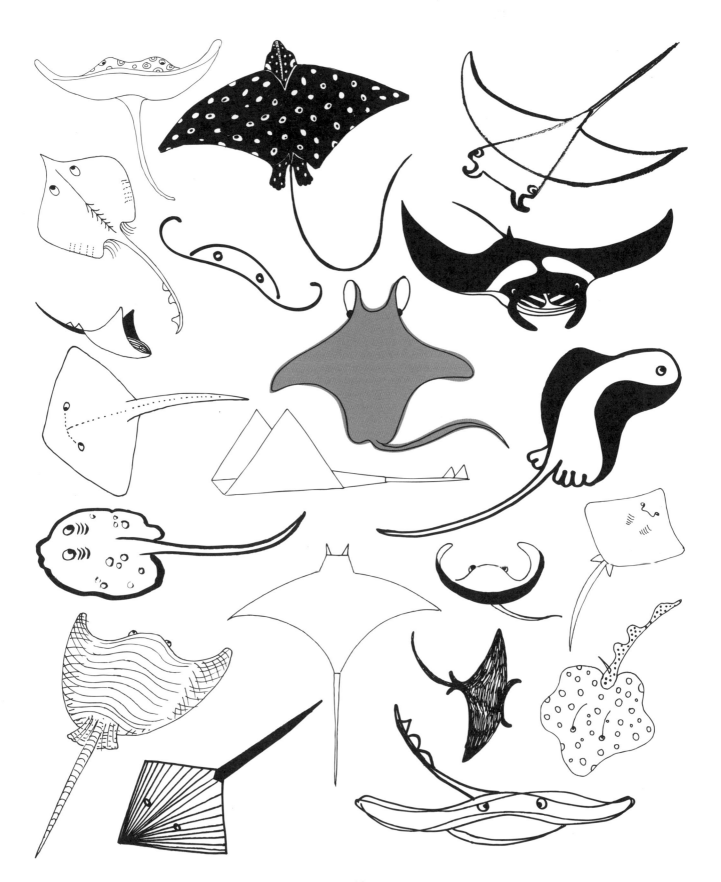

DRAW 20
Rays

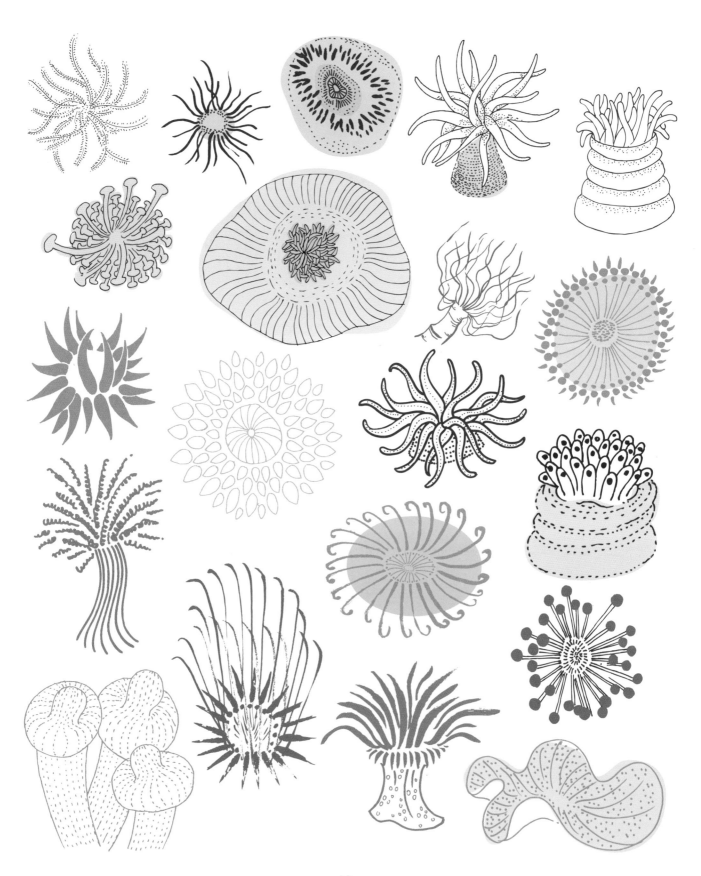

DRAW 20
Anemones

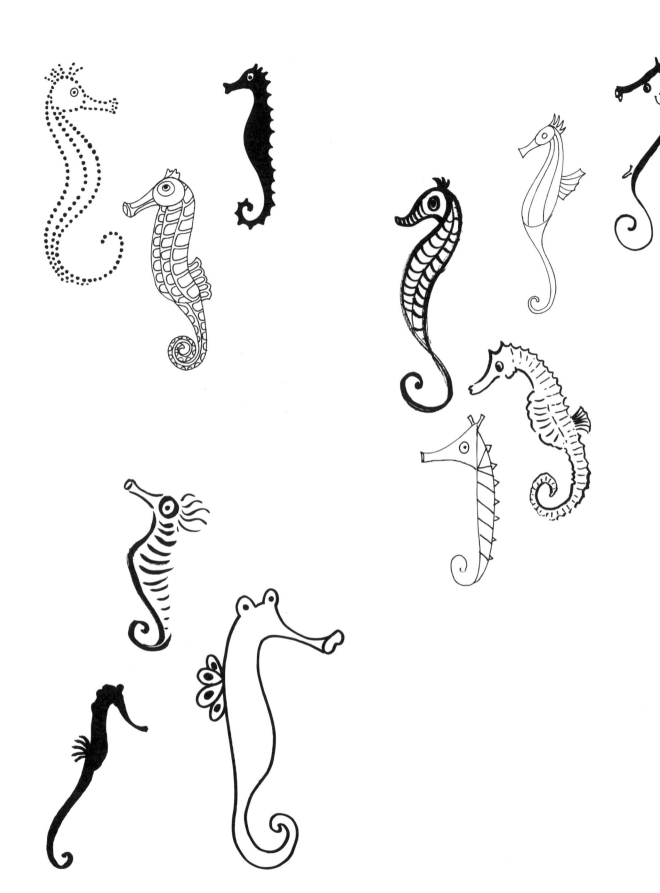

DRAW 20
SEAHORSES

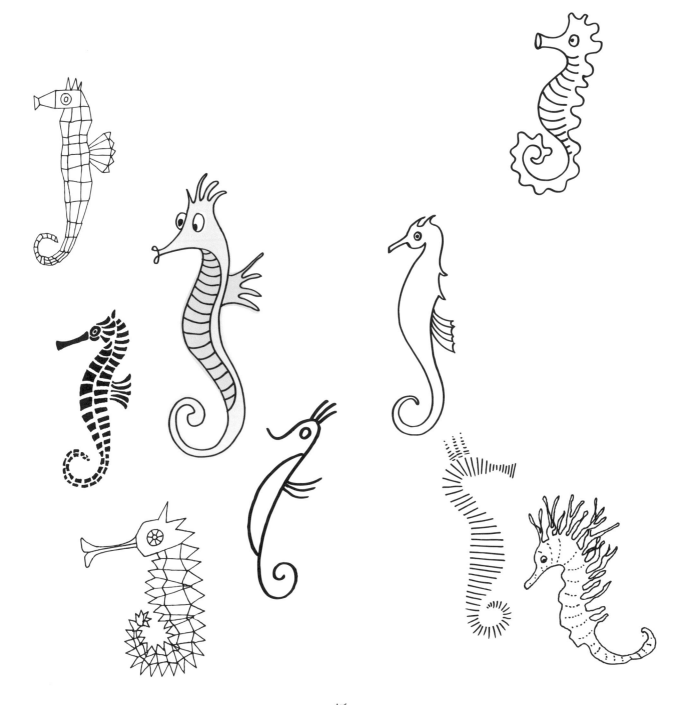

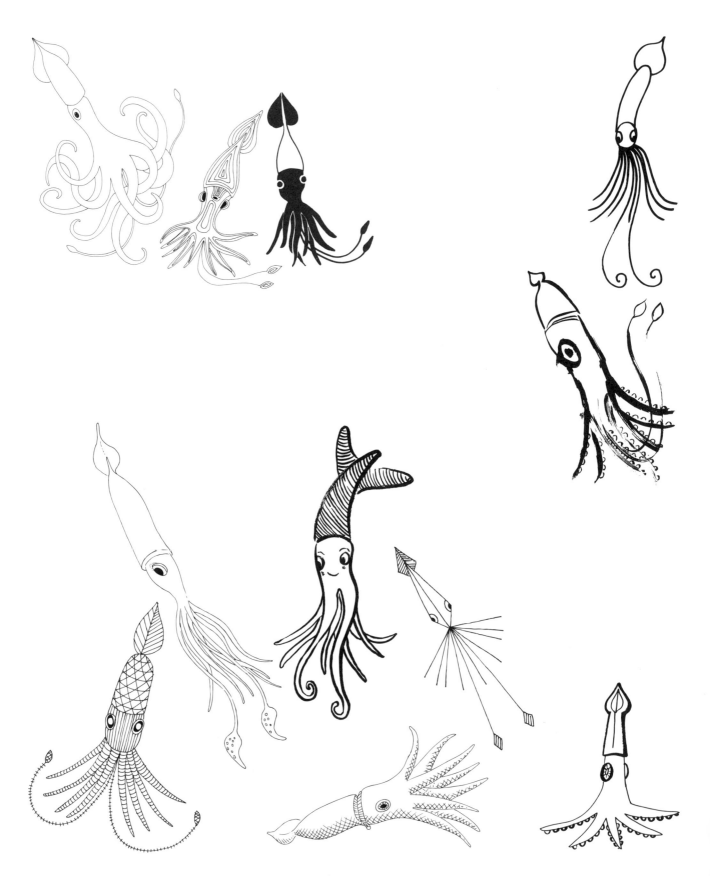

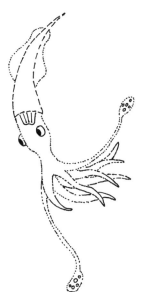

DRAW 20
SQUID

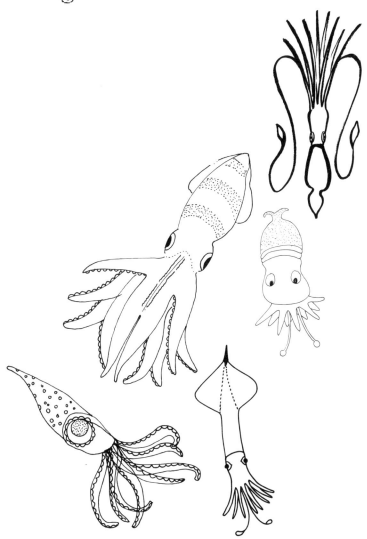

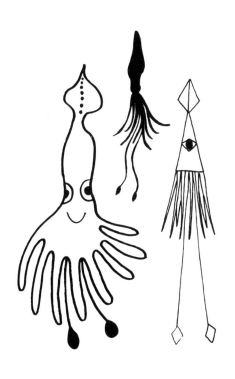

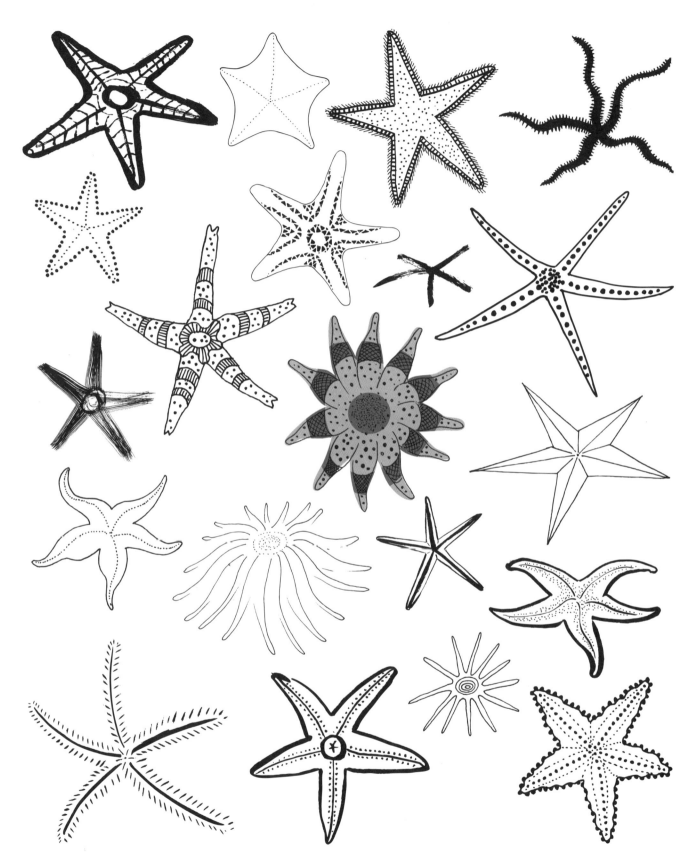

DRAW 20
Starfish

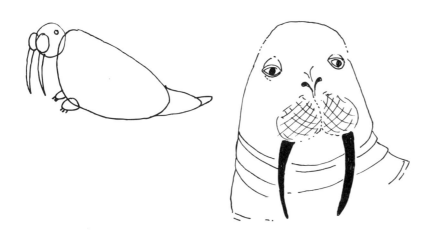

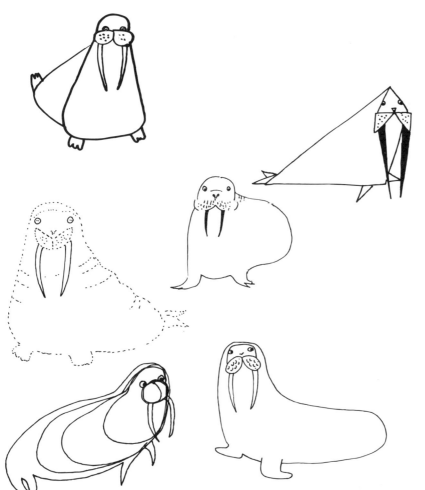

DRAW 20
WALRUSES

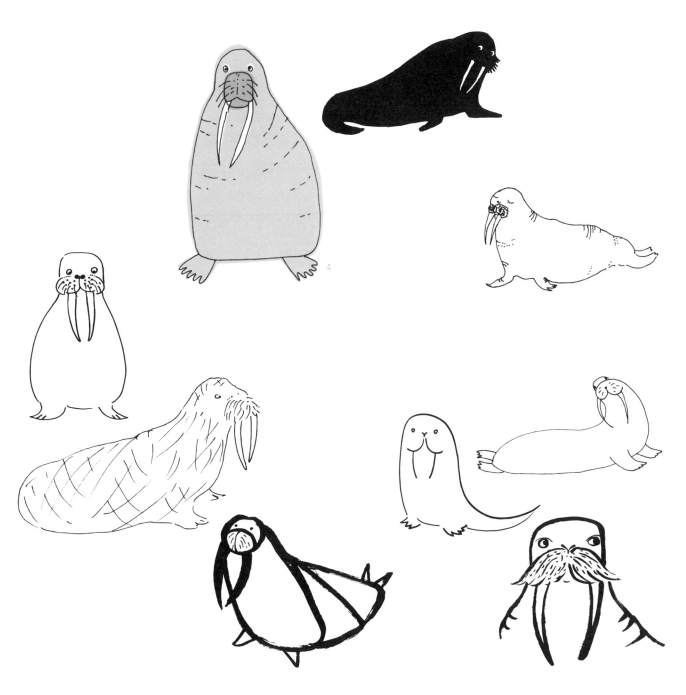

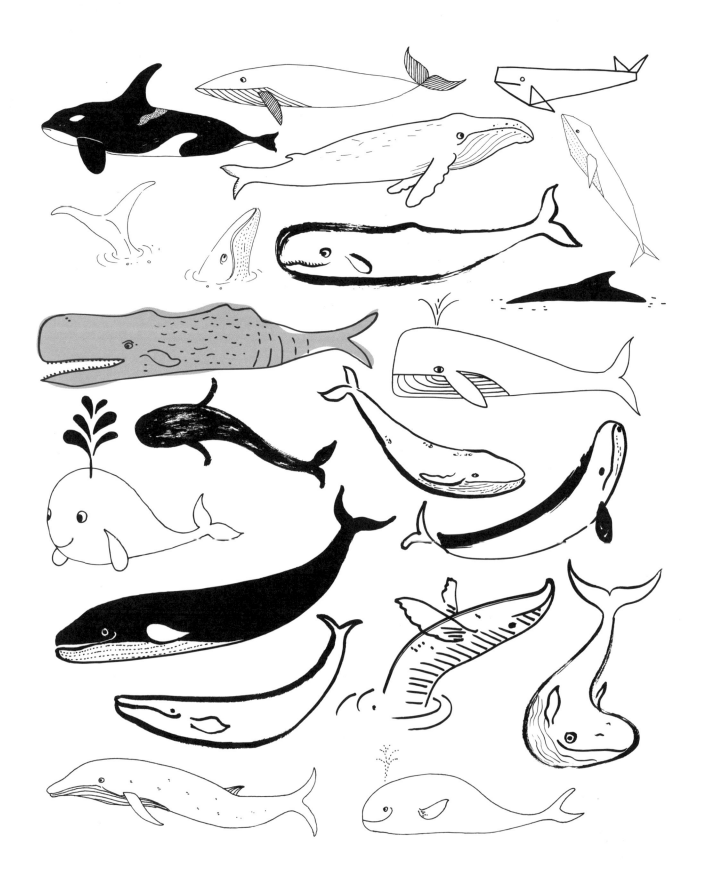

DRAW 20
Whales

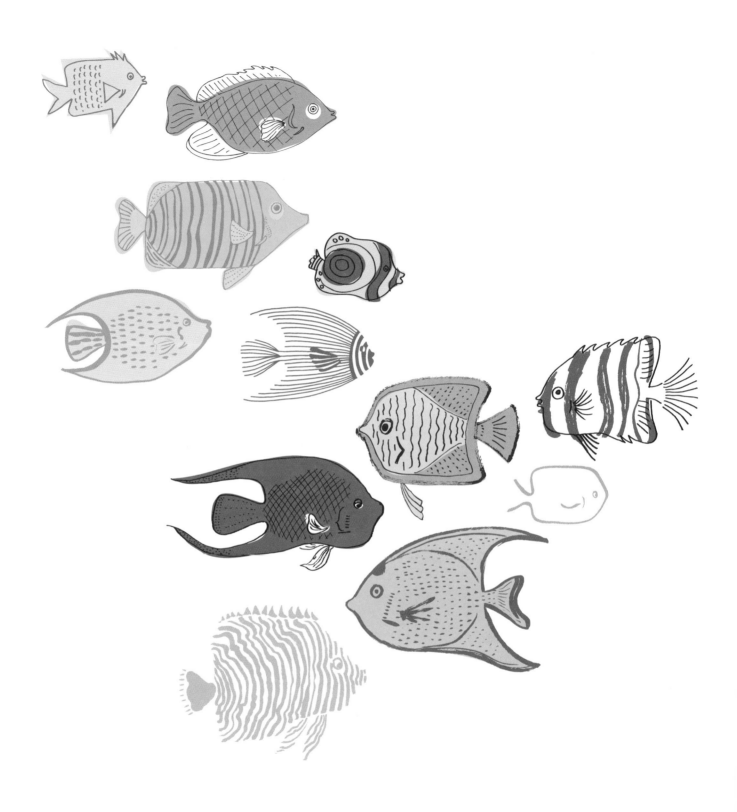

DRAW 20
Angelfish

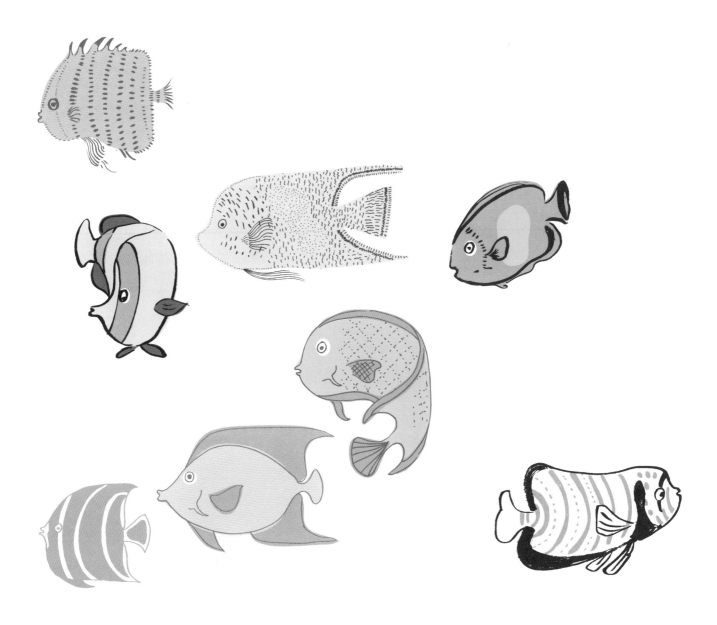

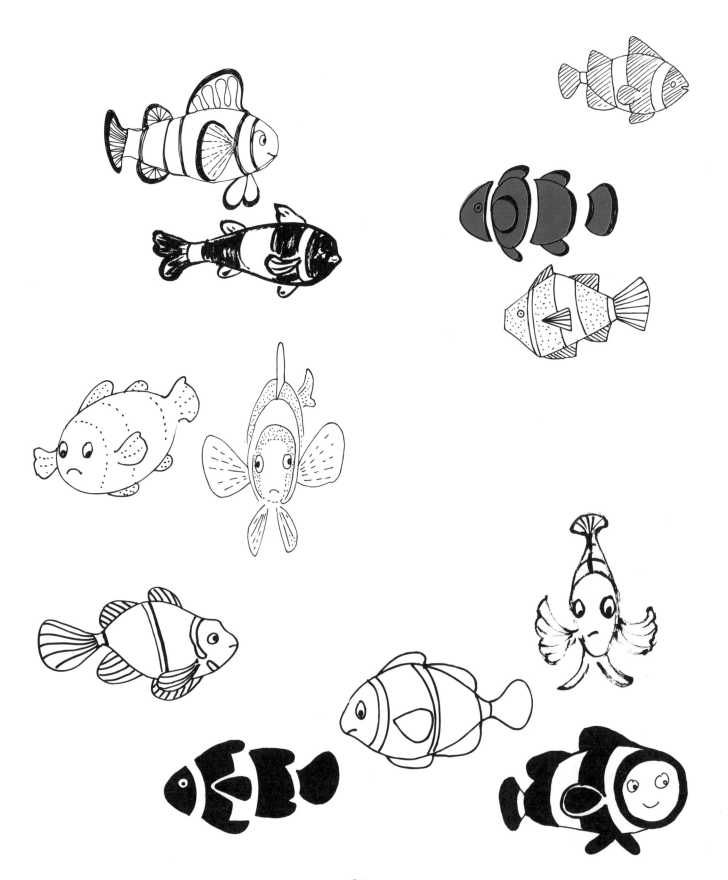

DRAW 20
CLOWN FISH

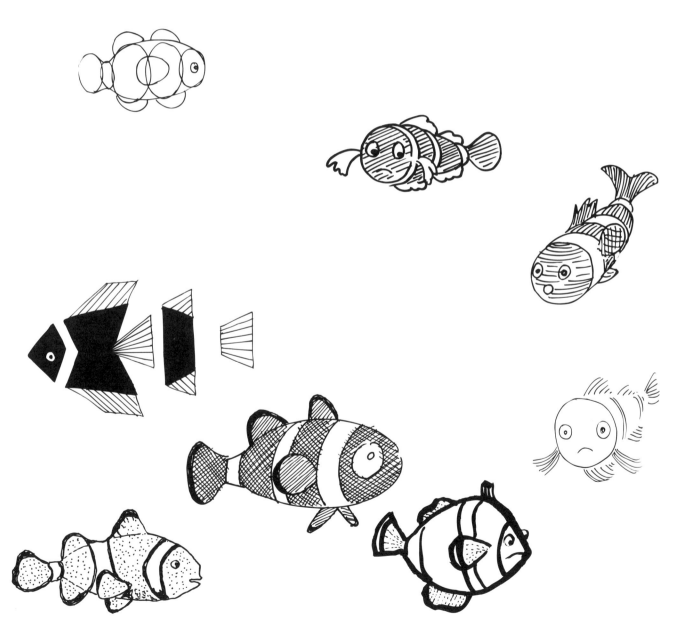

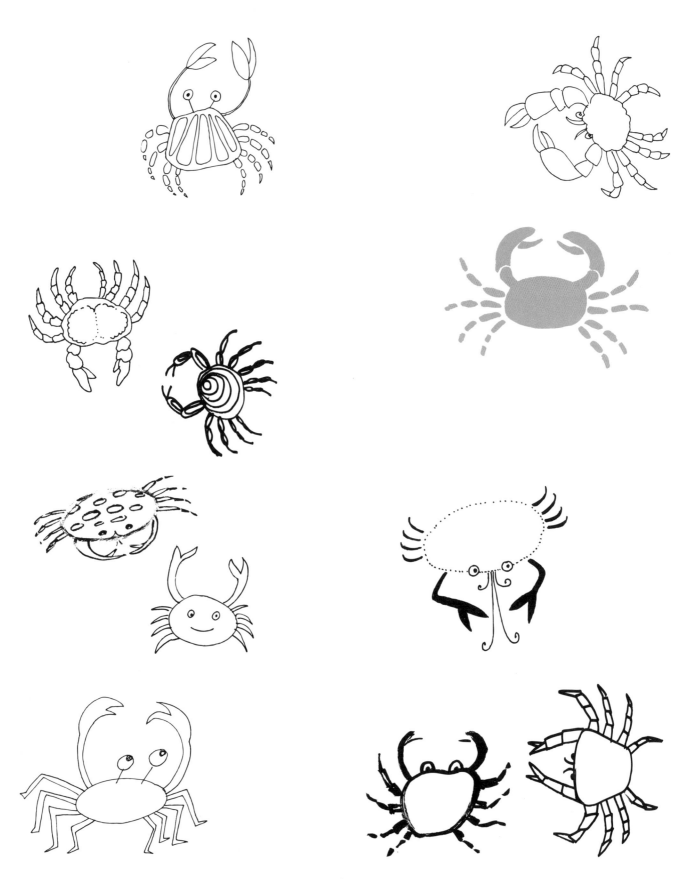

DRAW 20
CRABS

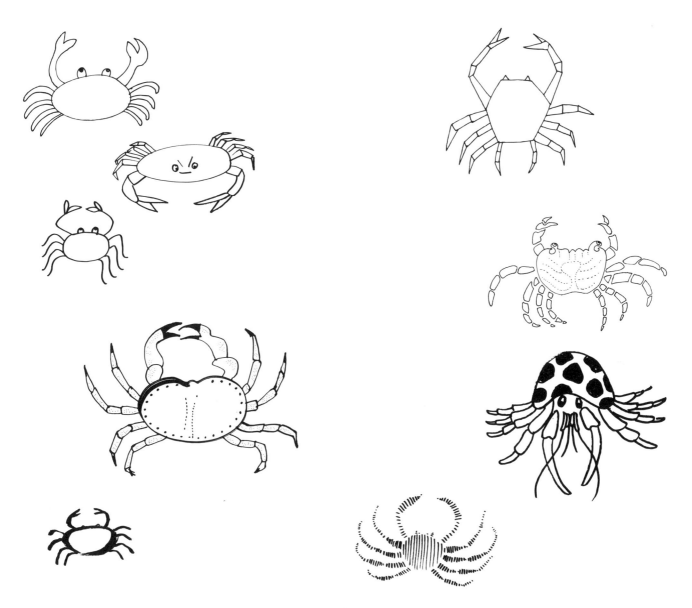

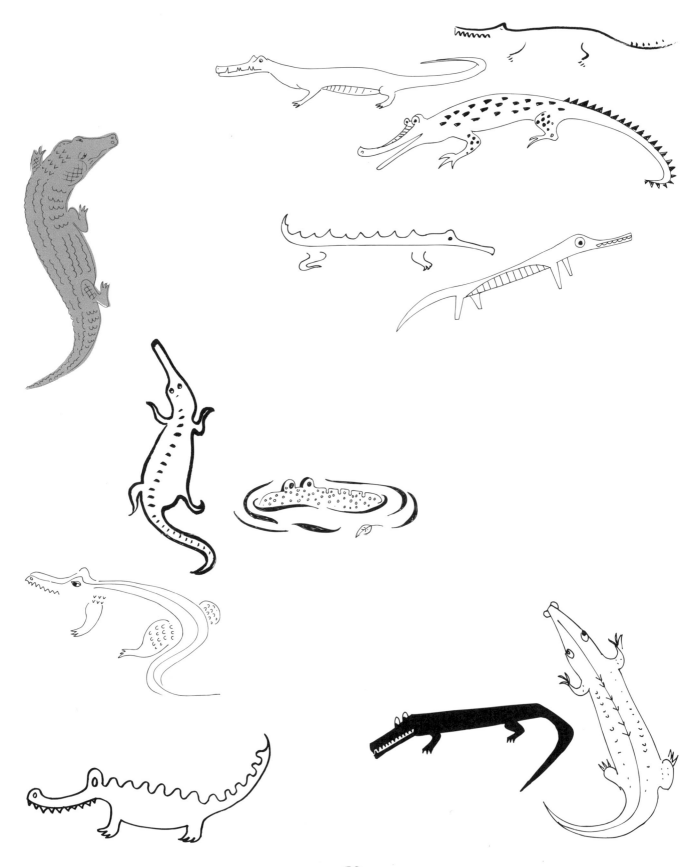

DRAW 20
CROCODILES

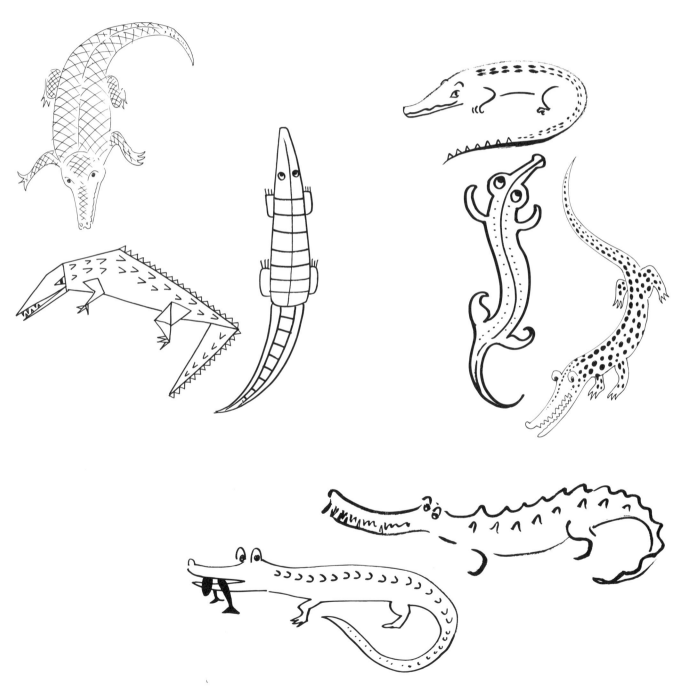

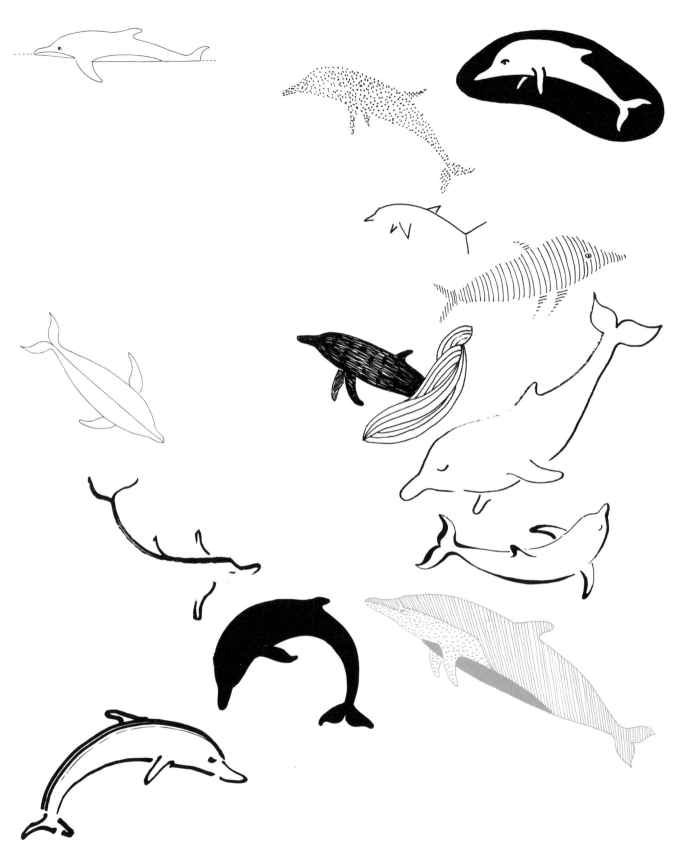

DRAW 20
Dolphins

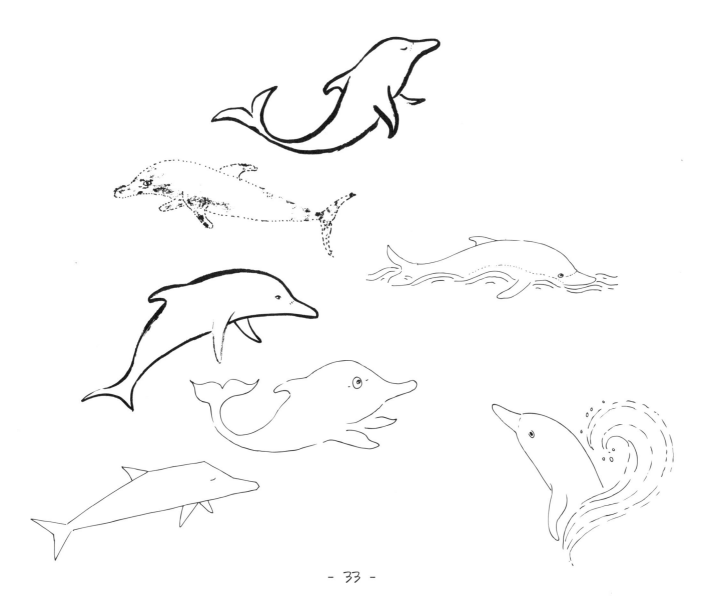

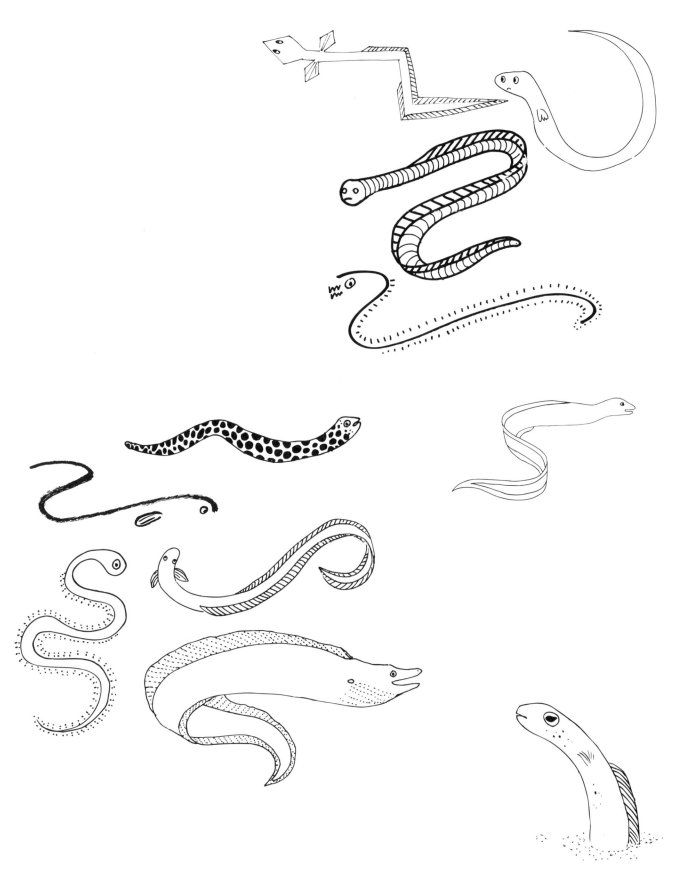

DRAW 20
eels

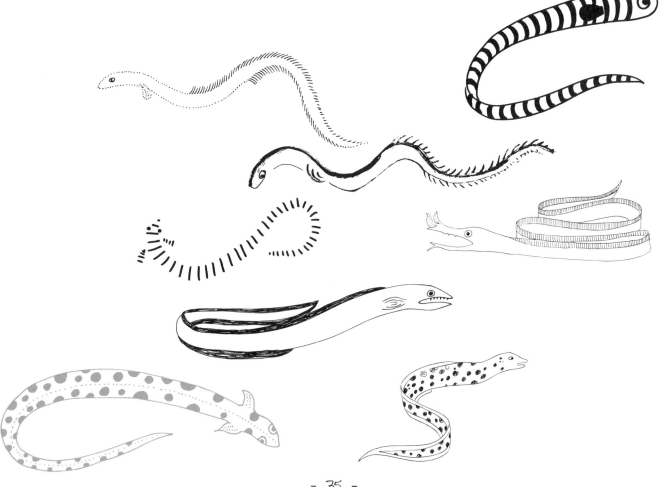

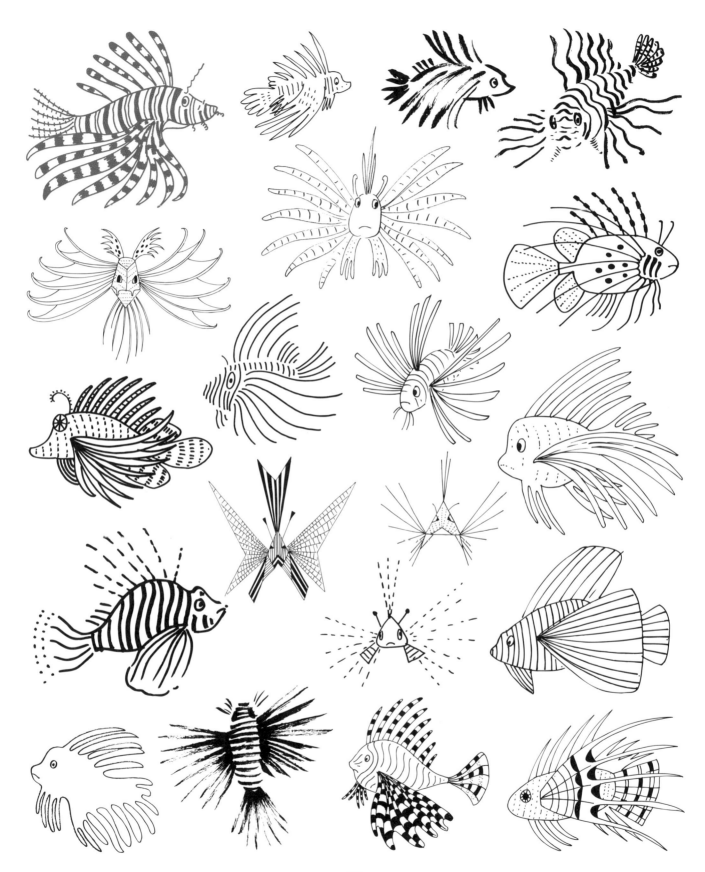

DRAW 20
Lionfish

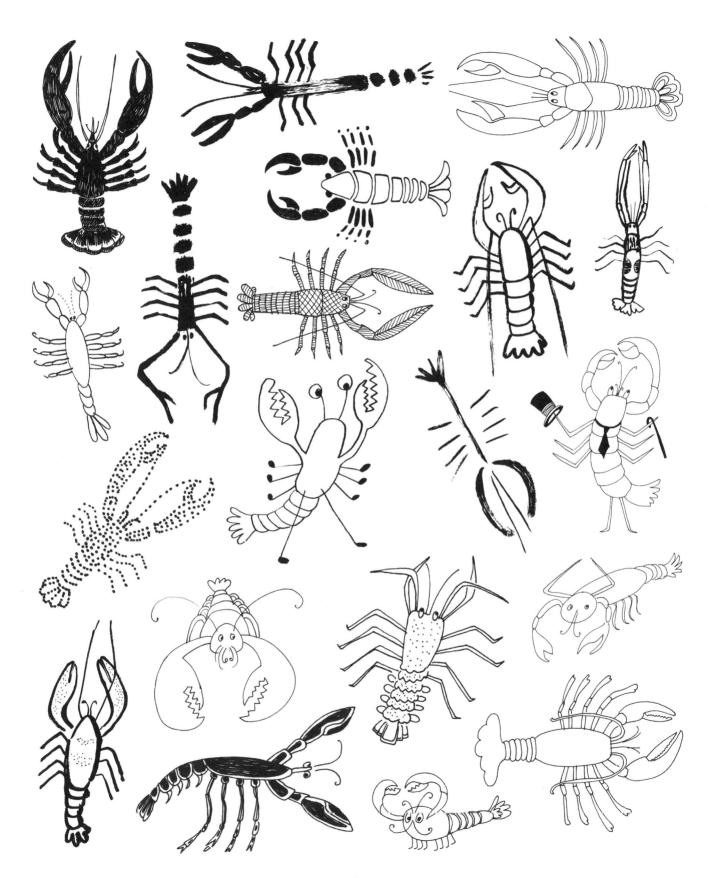

DRAW 20
LOBSTERS

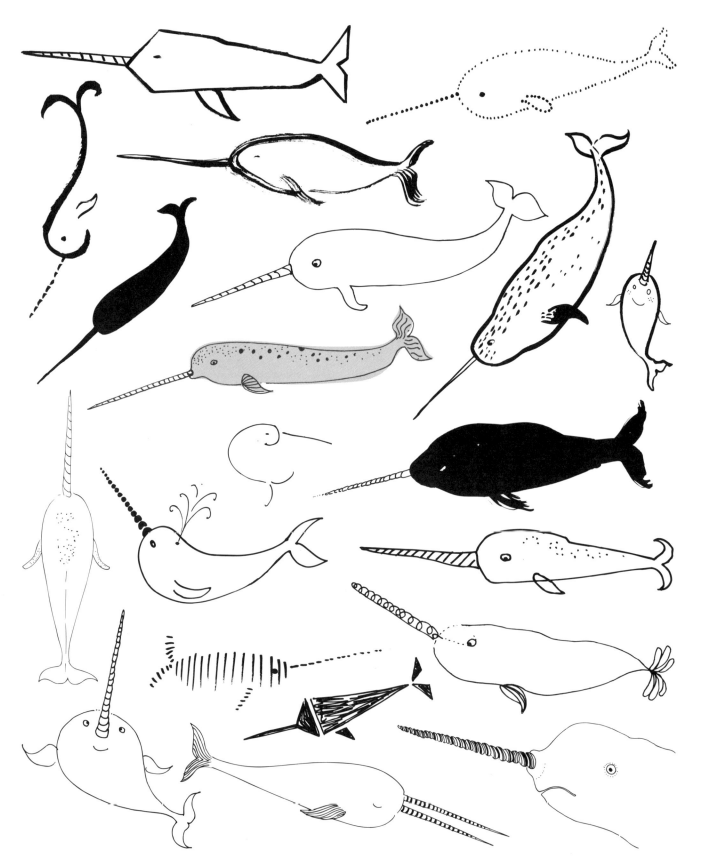

DRAW 20
NARWHALS

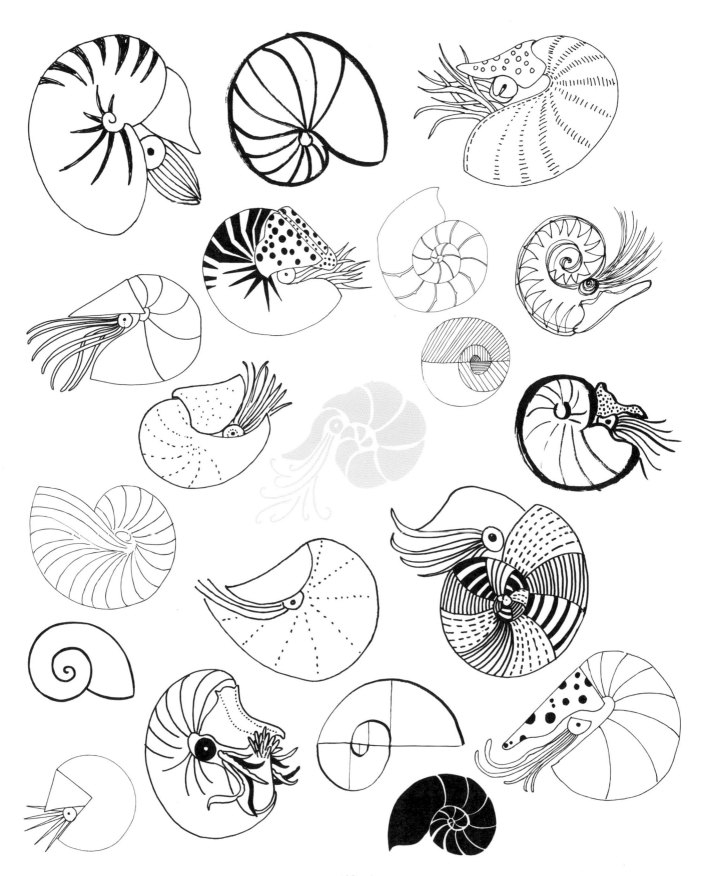

DRAW 20
Nautiluses

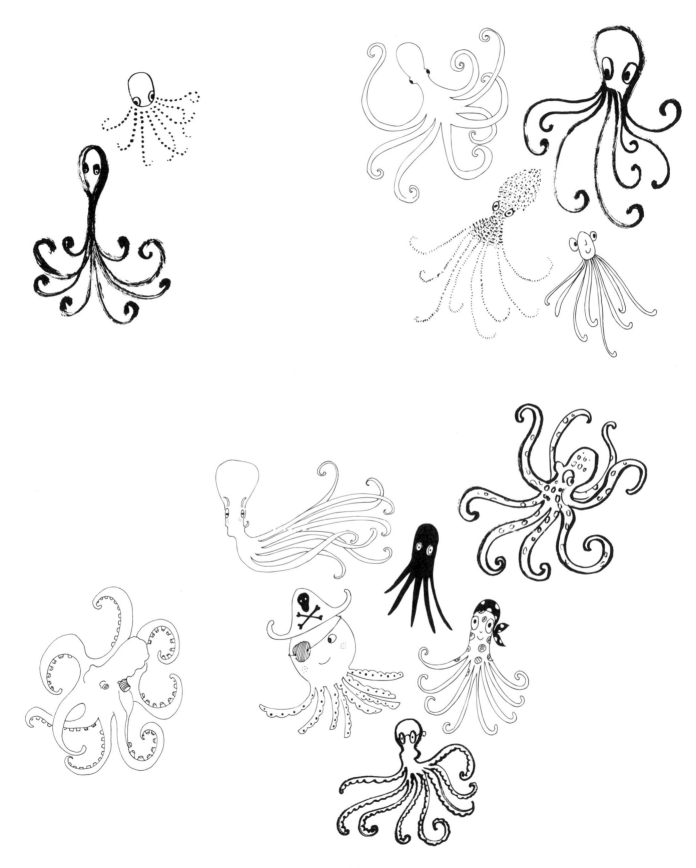

DRAW 20
Octopi

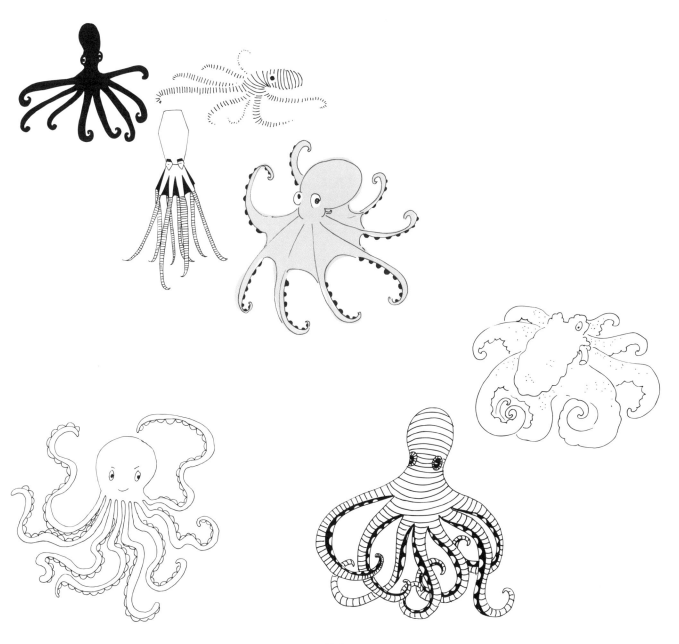

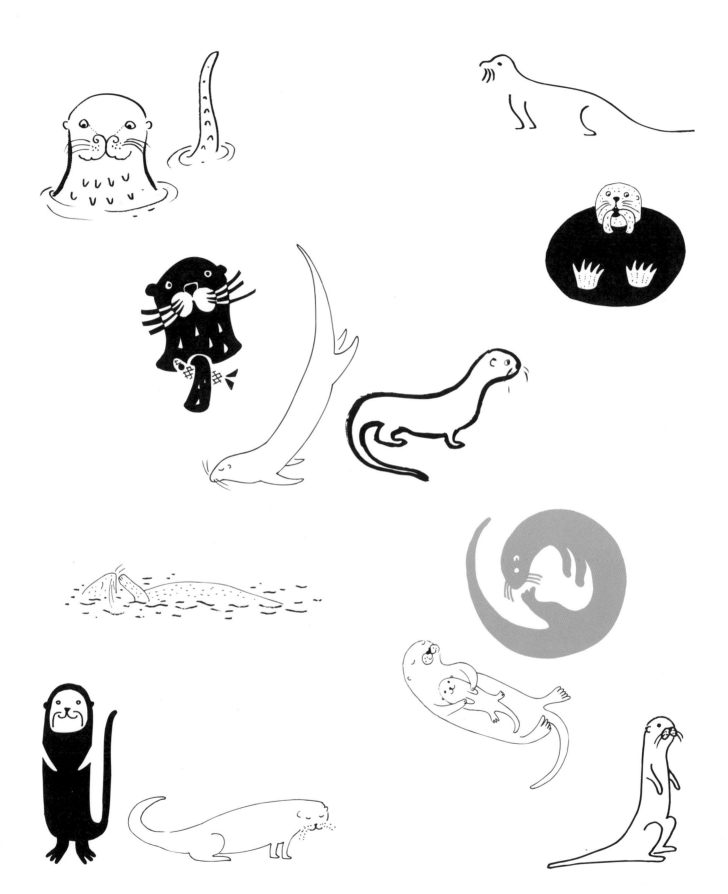

DRAW 20
SEA OTTERS

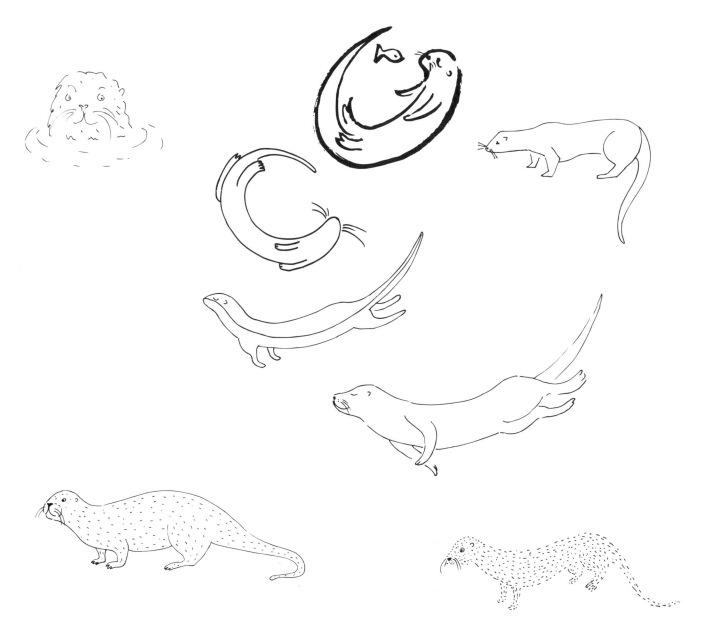

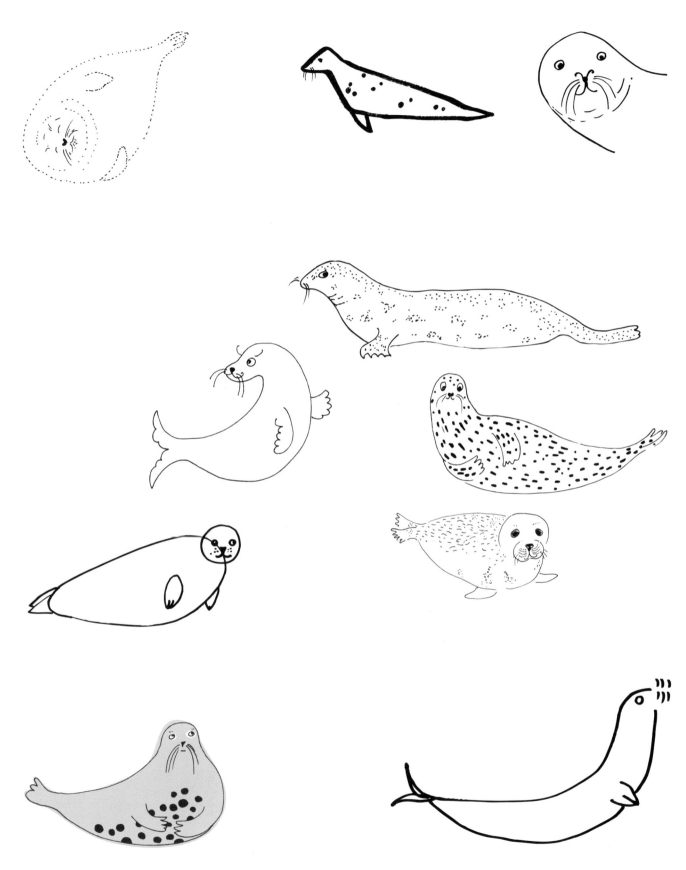

DRAW 20
Seals

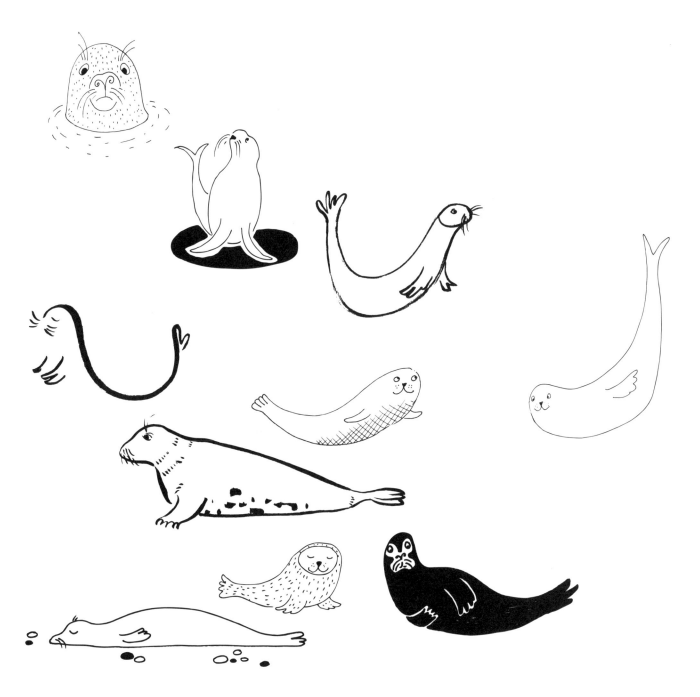

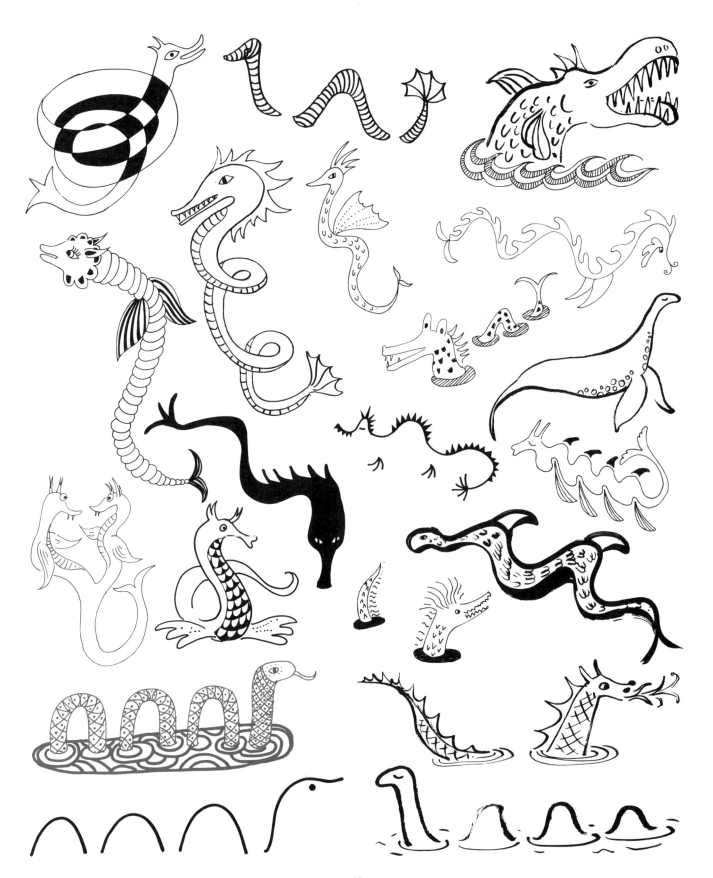

DRAW 20
Sea Serpents

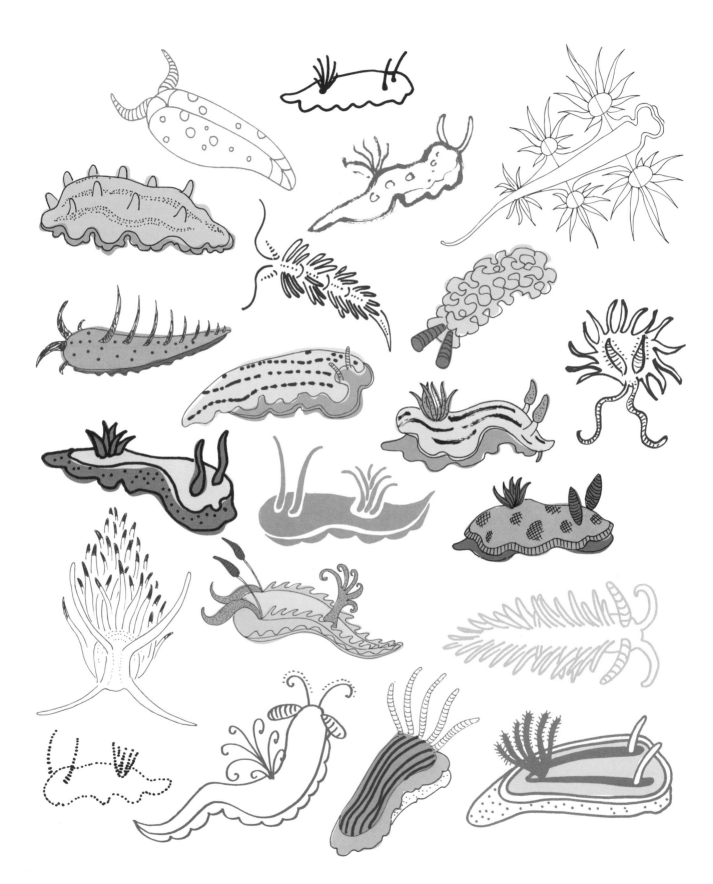

DRAW 20
sea slugs

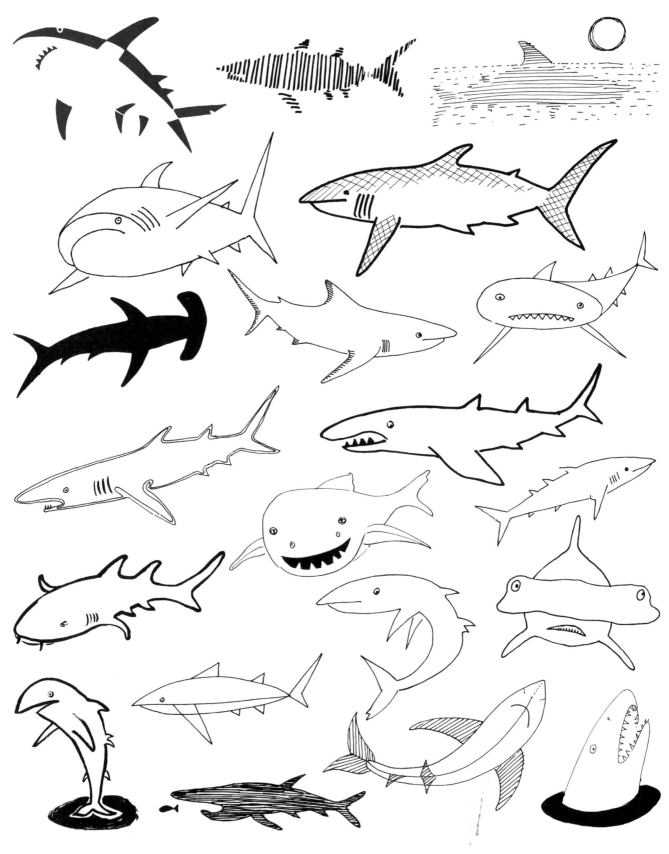

DRAW 20
Sharks

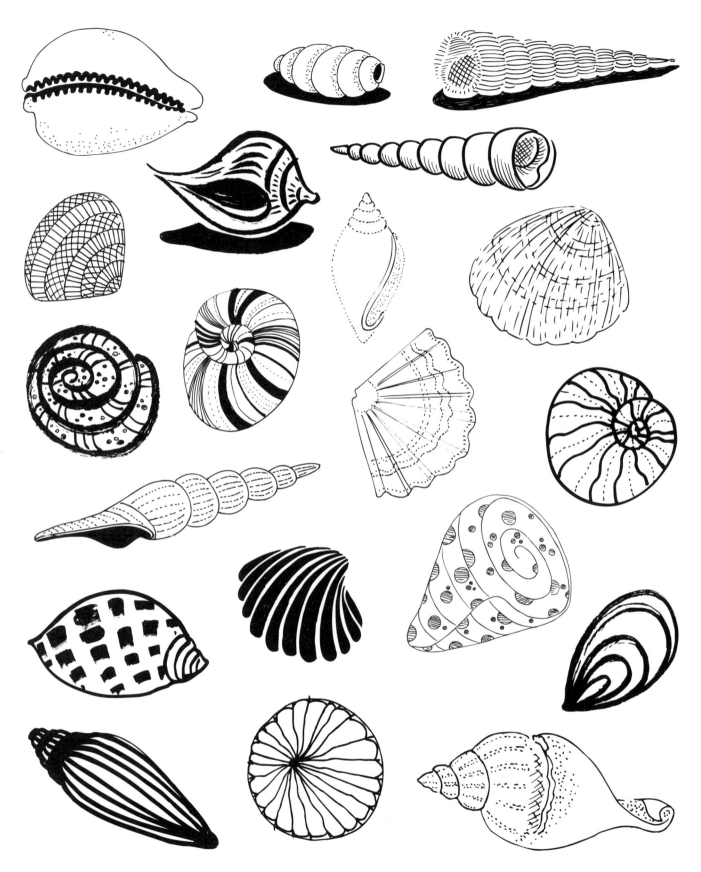

DRAW 20
seashells

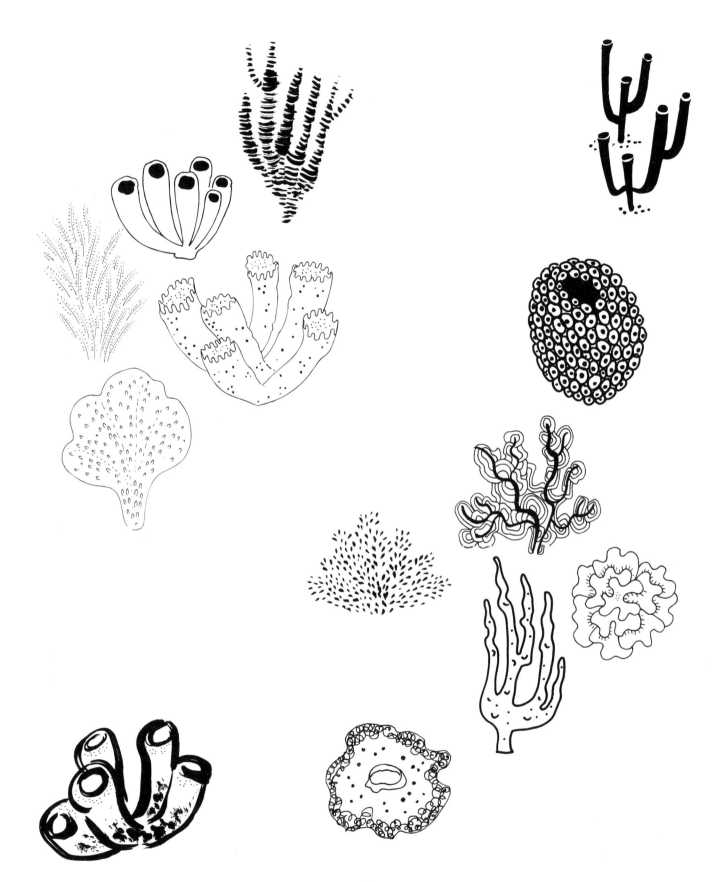

DRAW 20
sponges

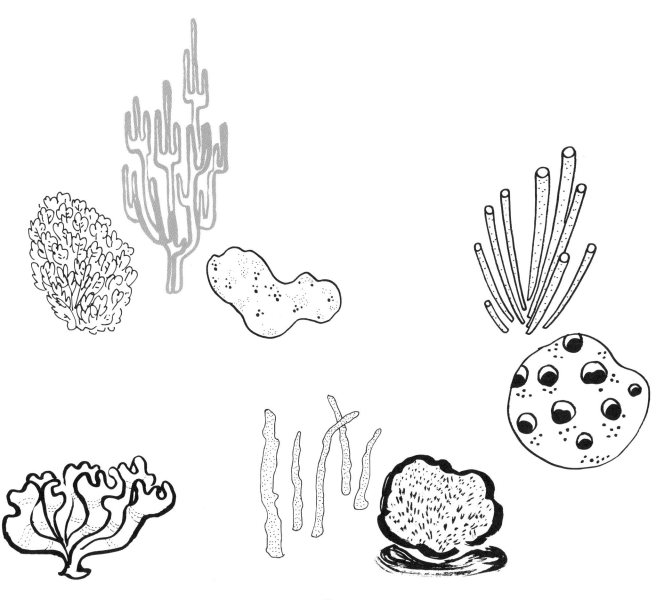

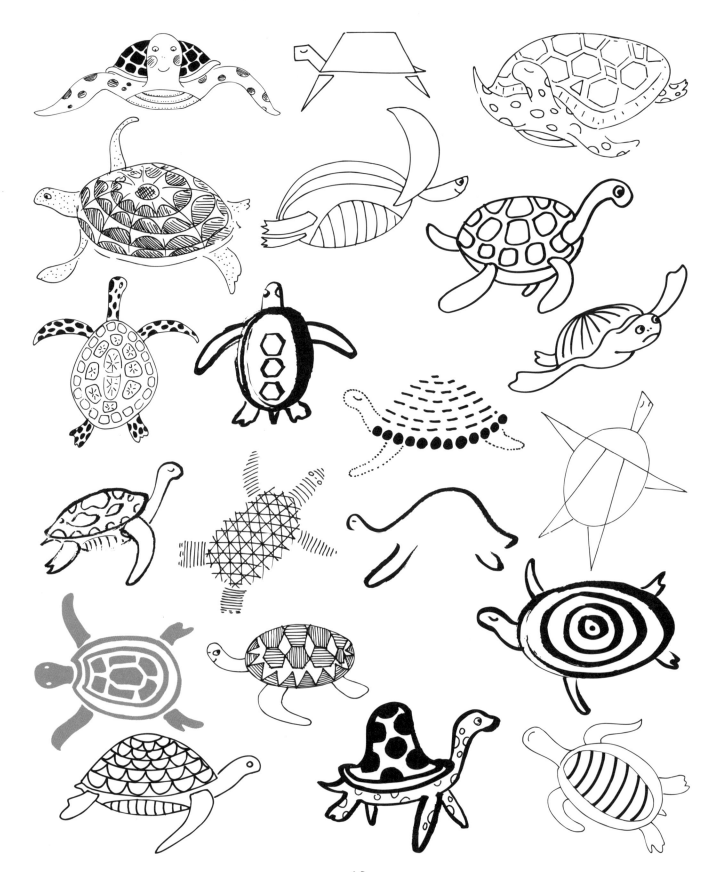

DRAW 20
SEA TURTLES

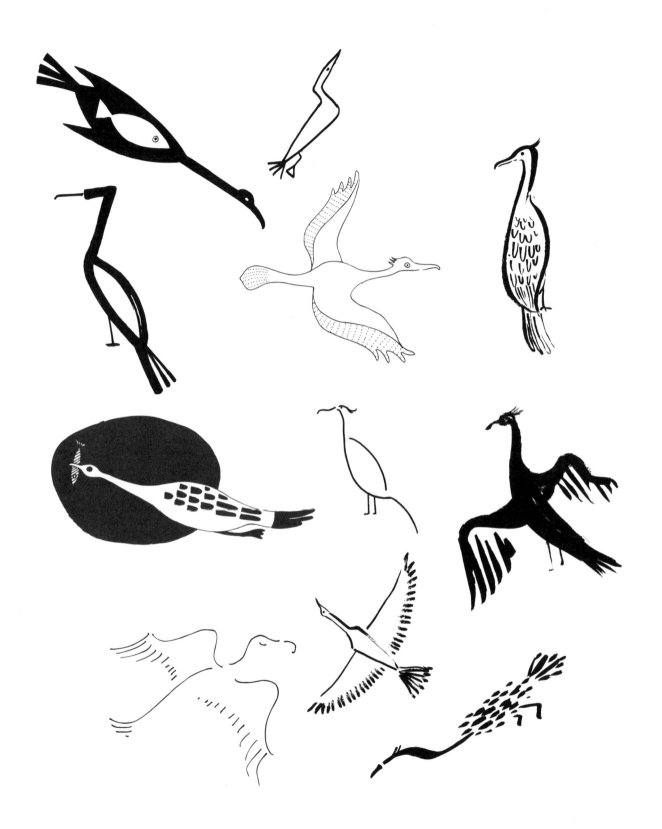

DRAW 20
Cormorants

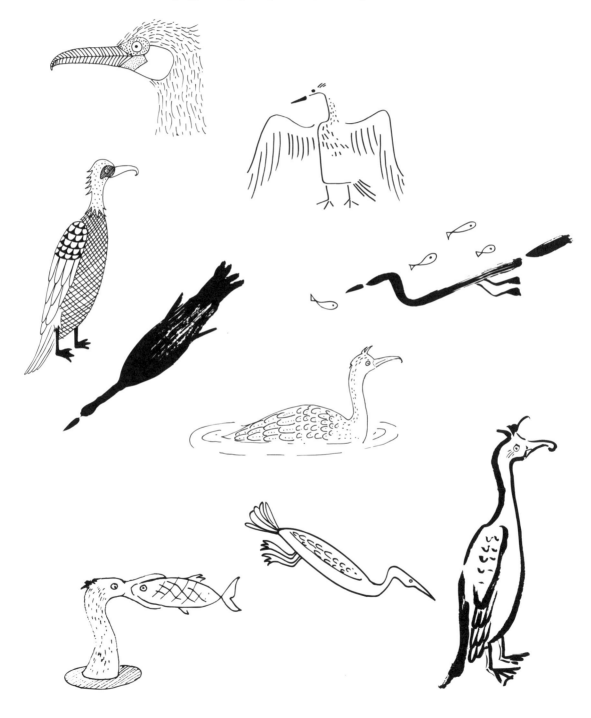

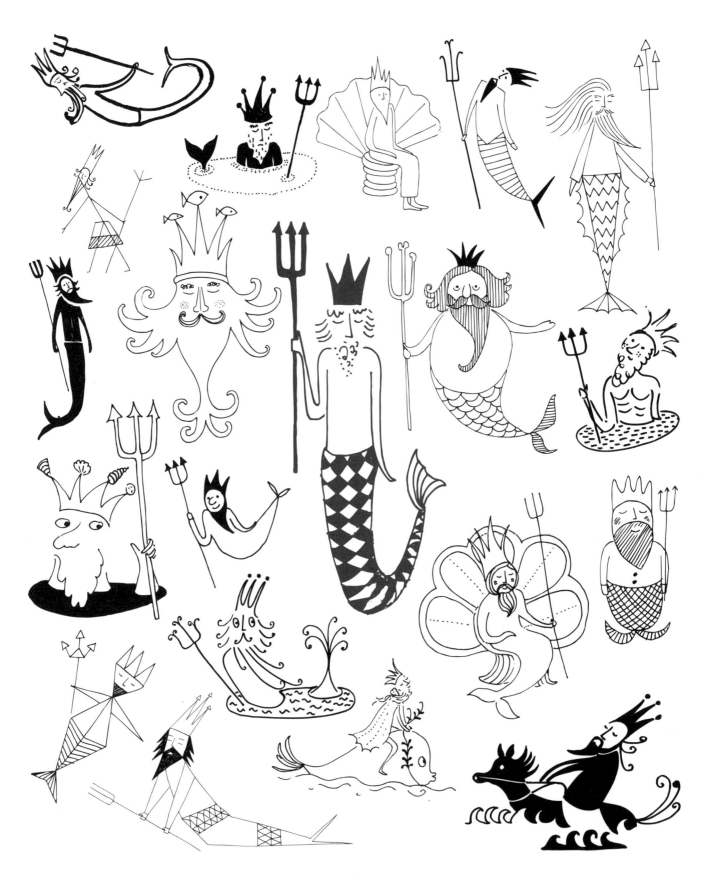

DRAW 20
KING NEPTUNES

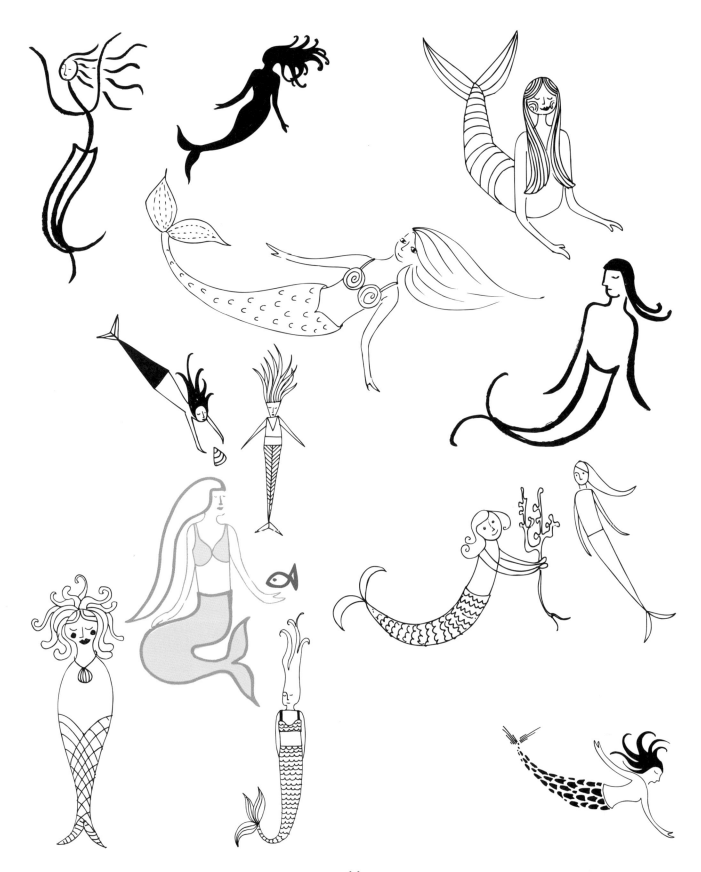

DRAW 20
Mermaids

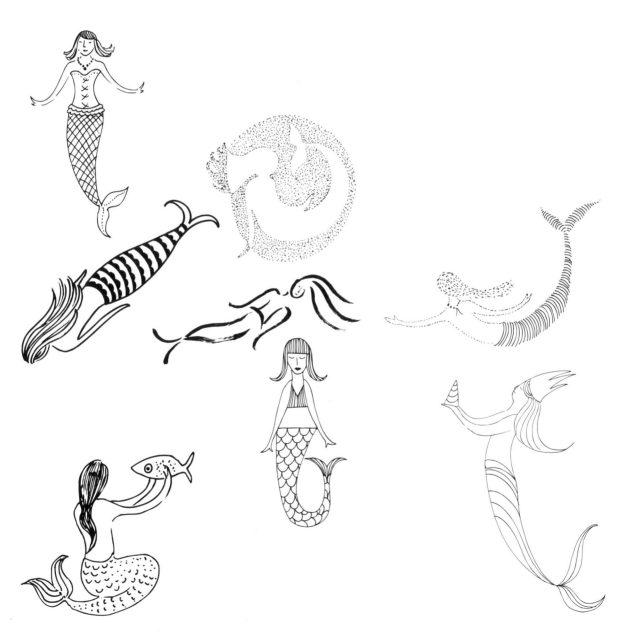

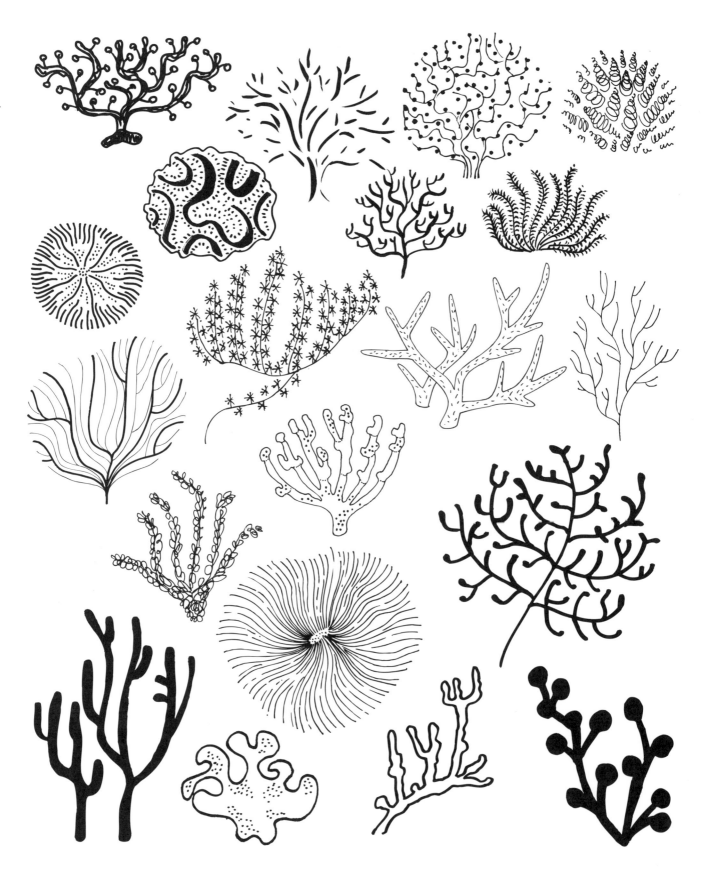

DRAW 20
Corals

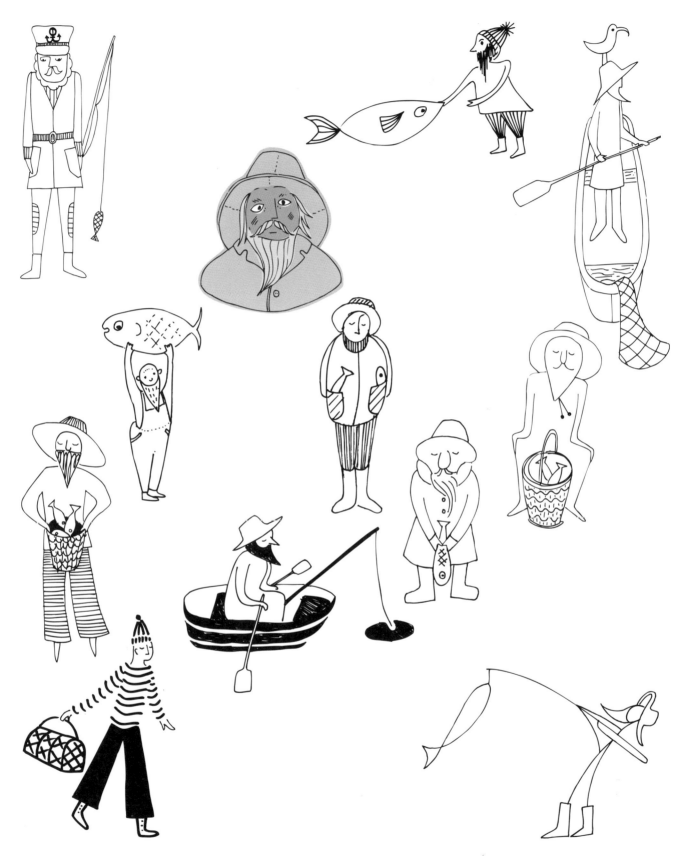

DRAW 20
FISHERMEN

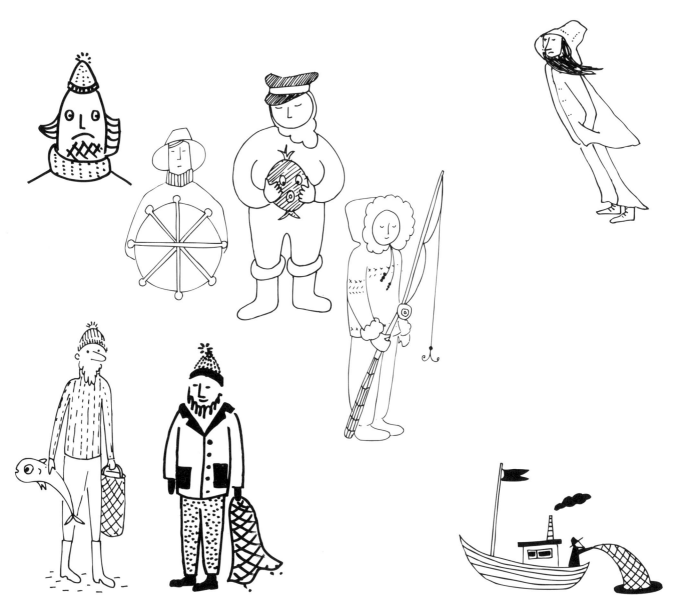

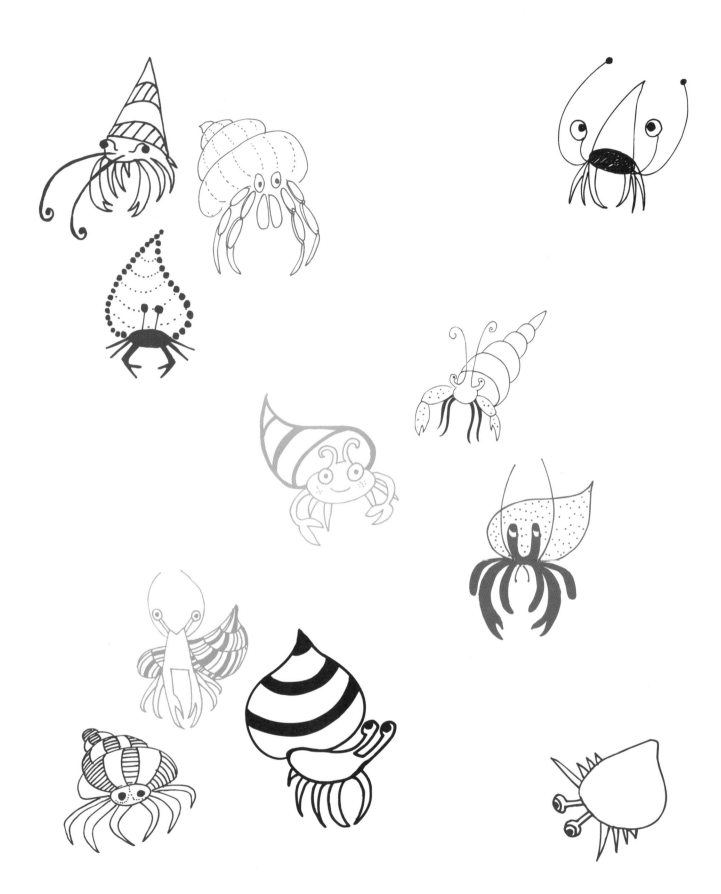

DRAW 20
Hermit Crabs

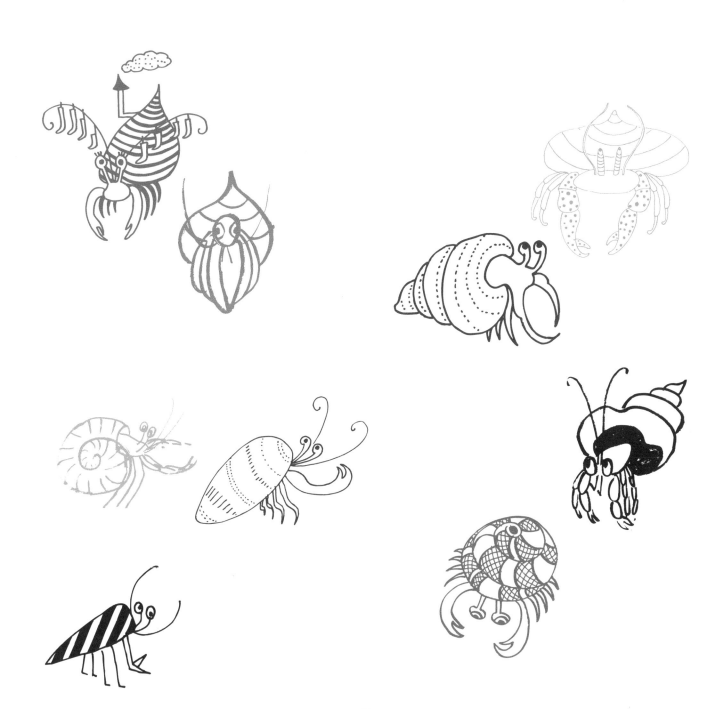

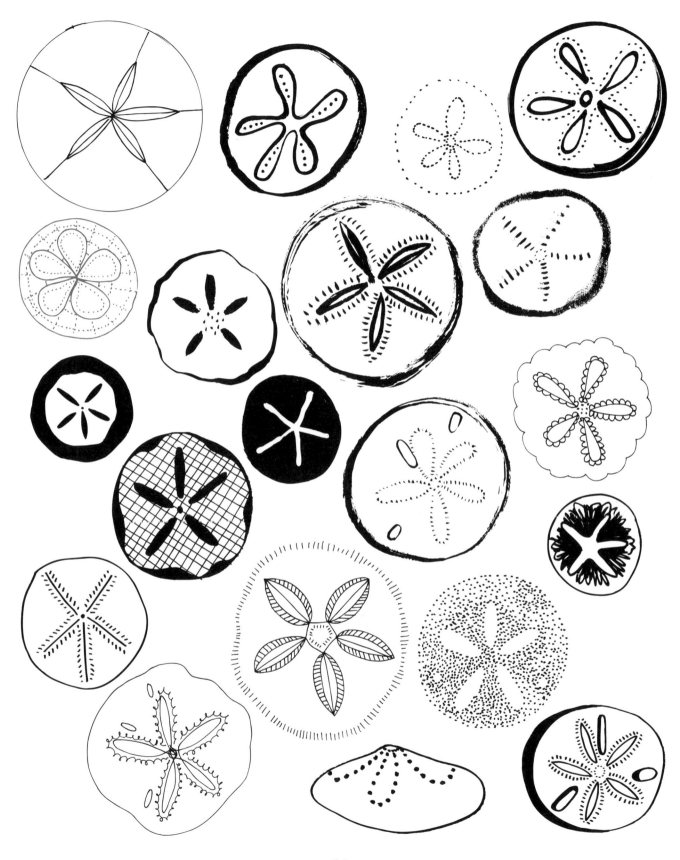

DRAW 20
Sand Dollars

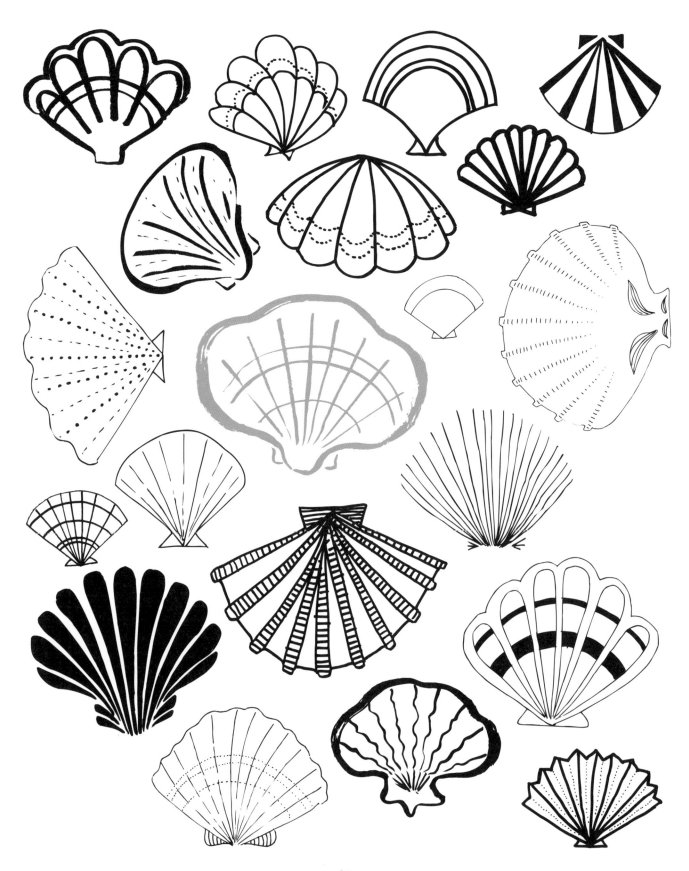

DRAW 20
scallops

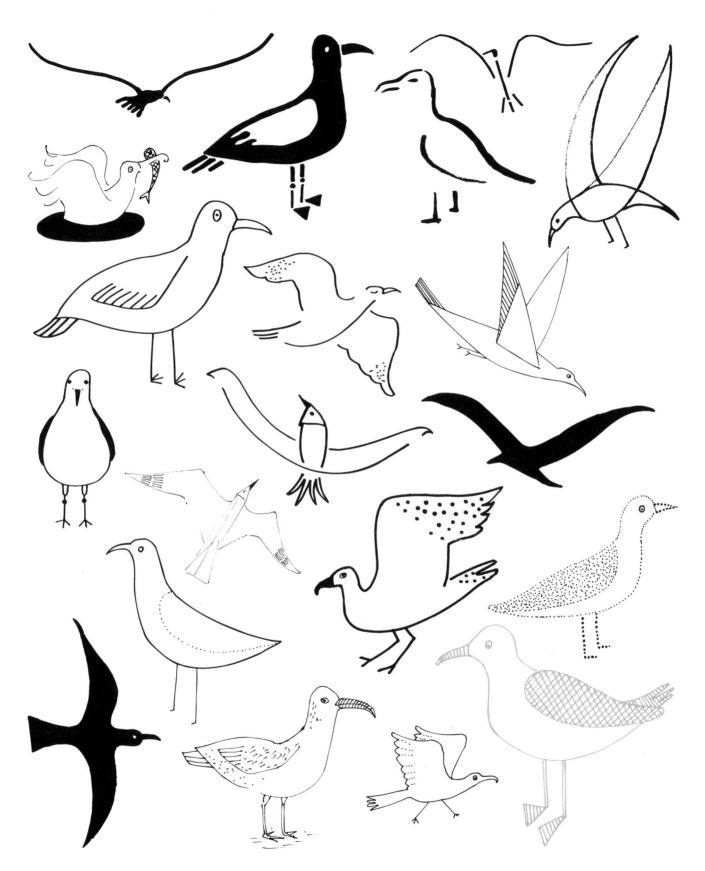

DRAW 20

Seagulls

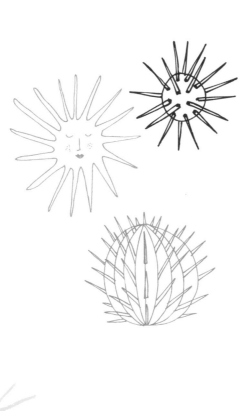
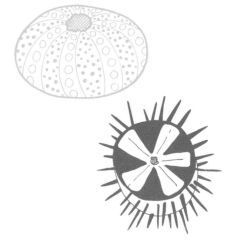

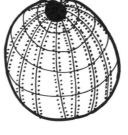
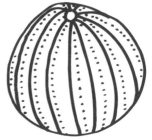

DRAW 20
Sea Urchins

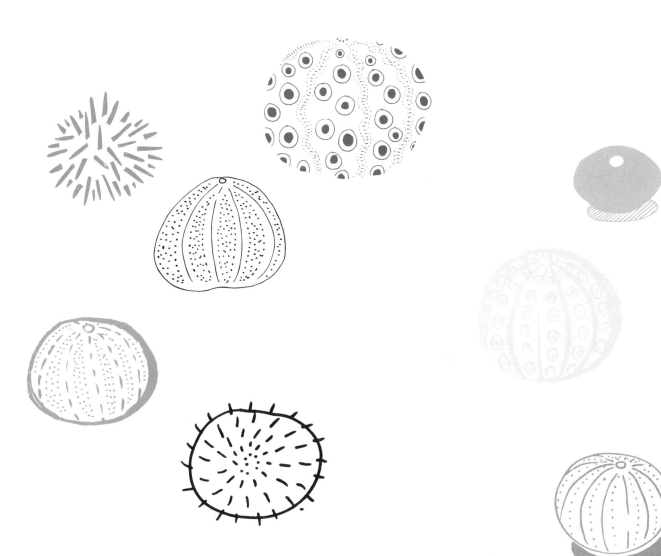

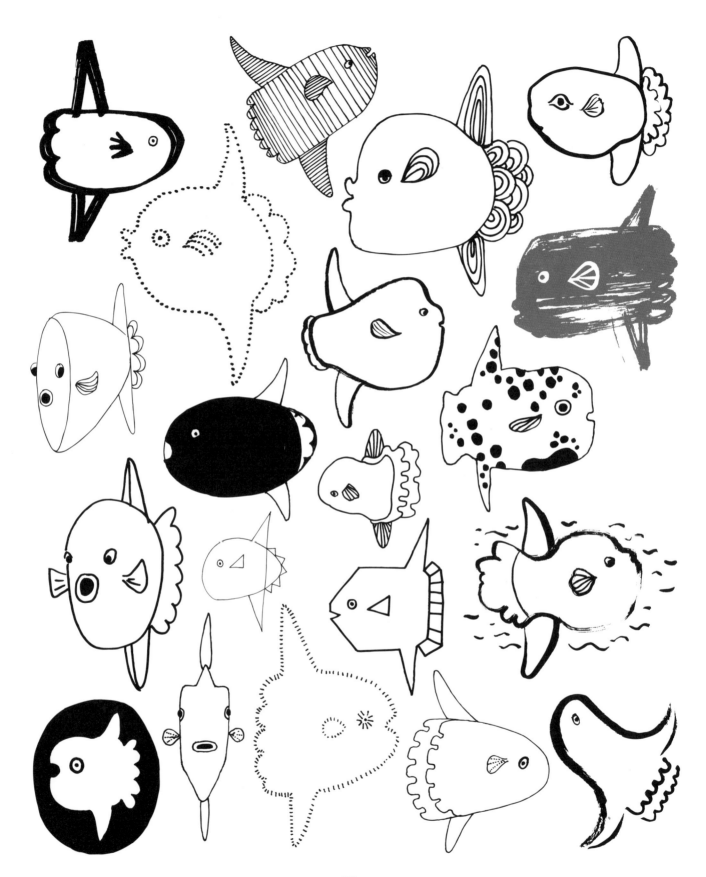

DRAW 20
SUNFISH

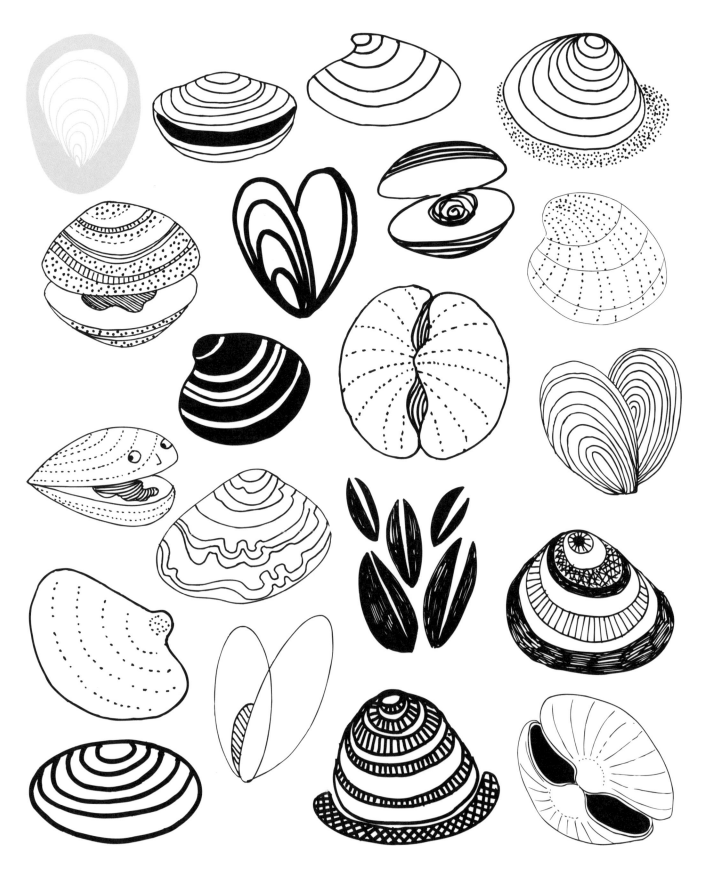

DRAW 20
Clams

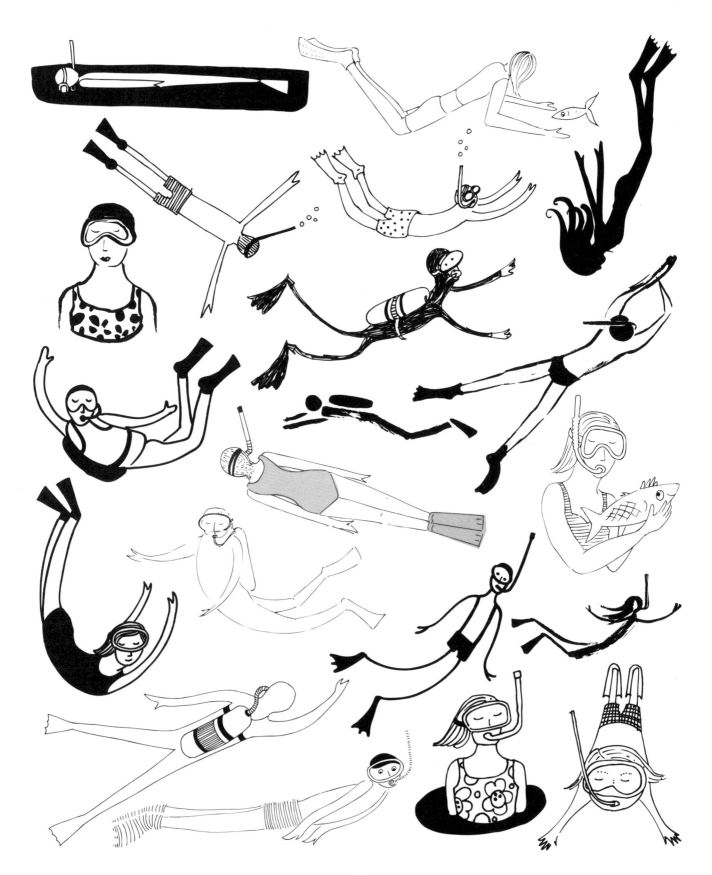

DRAW 20
Scuba Divers

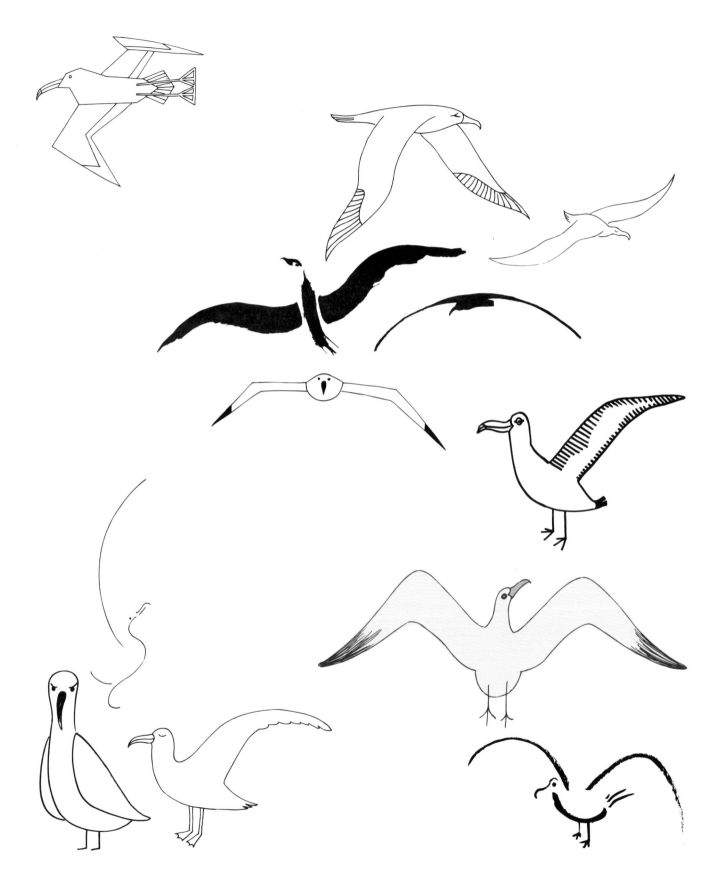

DRAW 20
ALBATROSS

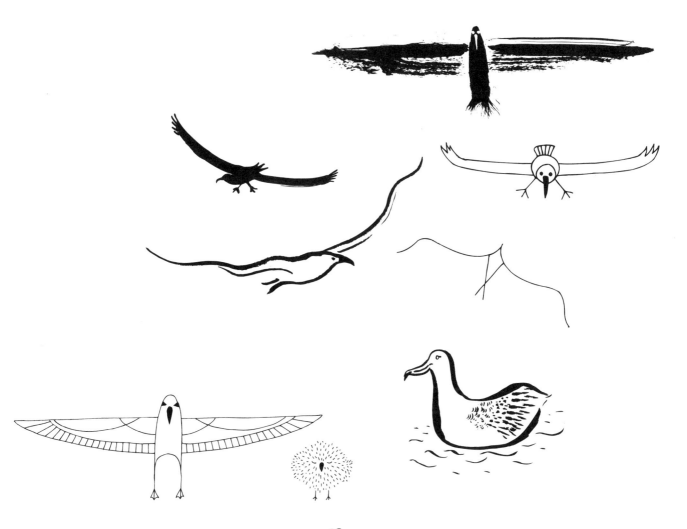

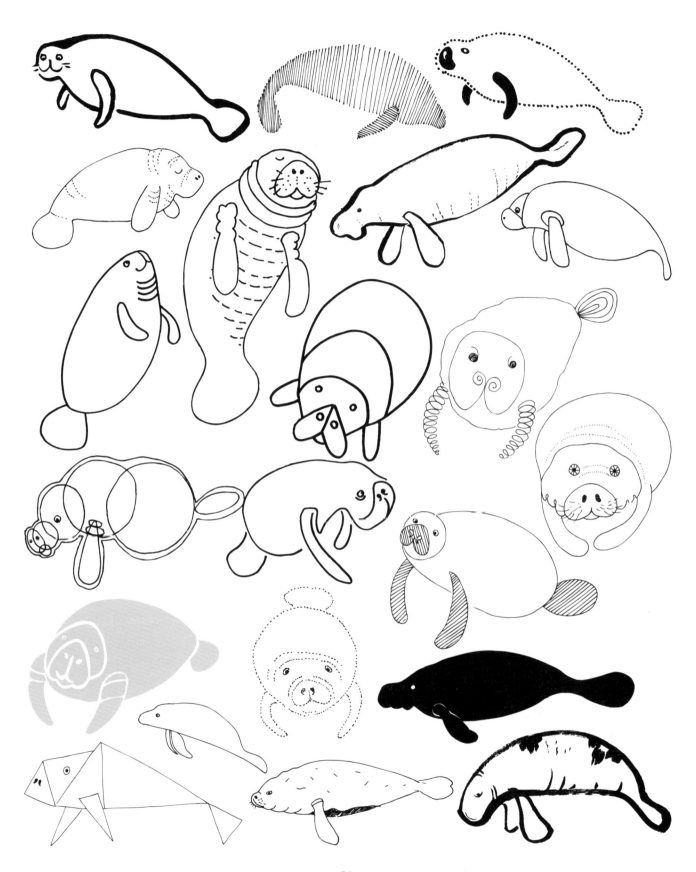

DRAW 20
manatees

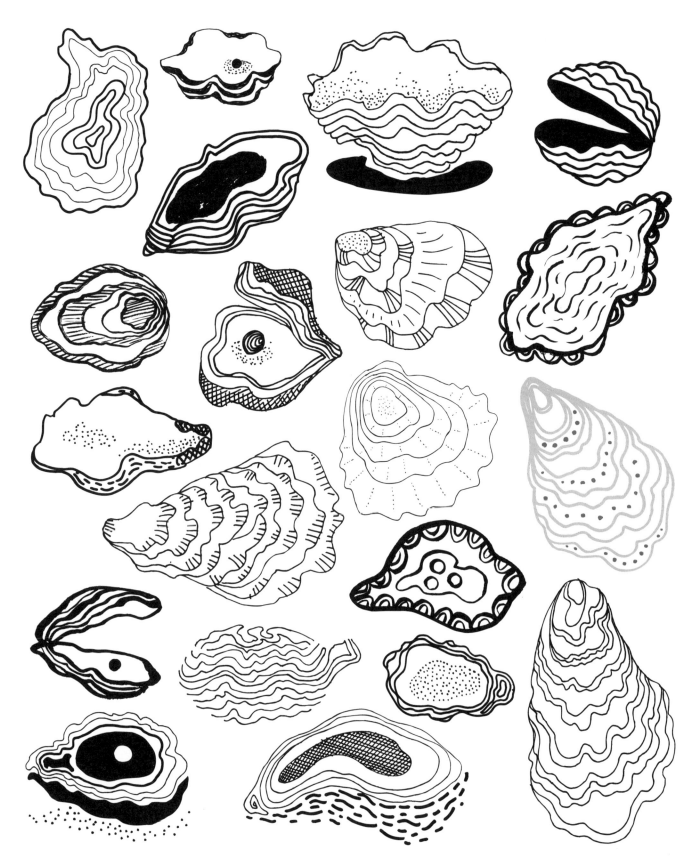

DRAW 20
OYSTERS

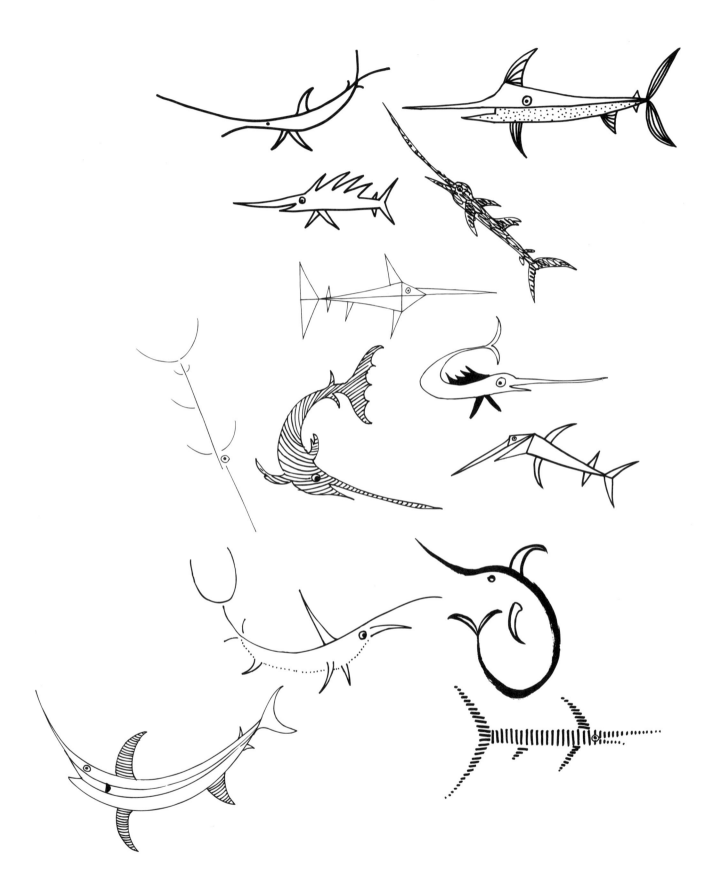

DRAW 20
Swordfish

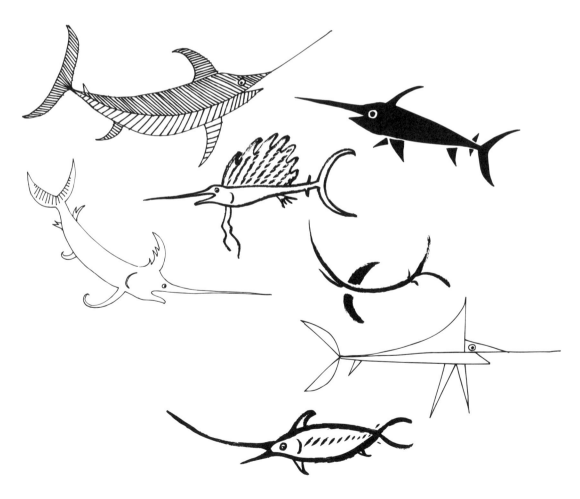

ABOUT THE ARTIST

Trina Dalziel is represented by illustration agency Lilla Rogers Studio. She lives in London and has worked as a freelance illustrator for over seventeen years.

Originally from the North of Scotland, she grew up on a tomato farm. She has studied illustration and also twentieth-century art and design history. In her teens and twenties she spent time living in the Netherlands, Copenhagen, Helsinki, and Paris. All of this has fed her love of art, design, nature, animals, and European cities.

Some of Trina's favorite things include dogs with beards, forests, walking slowly in nature, and wandering around cities with her camera.

She is also the featured artist in *20 Ways to Draw a Butterfly and 44 Other Things with Wings*, Quarry Books, 2014.

www.trinadalziel.com